of A

ARLINGTON HEIGHTS
ILLINOIS
DOWNTOWN RENAISSANCE

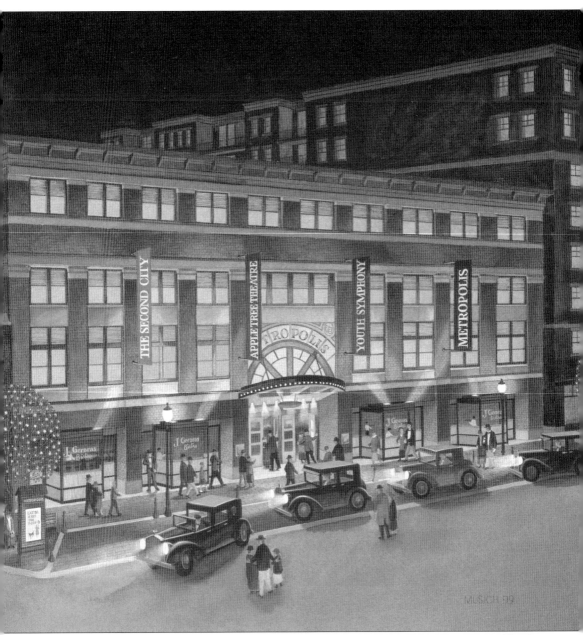

This painting by local artist Jack Musich signifies the Arlington Heights of yesteryear, blending with the sophistication of today's village. Automobiles from the 1920s are discharging their passengers in front of the Metropolis Performing Arts Center, which opened in 2000, on West Campbell Street. Developer Mark Anderson, a major player in the redesign of the Arlington Heights Central Business District, conceived the Center. (Painting courtesy of Mark Anderson.)

IMAGES
of America

ARLINGTON HEIGHTS
ILLINOIS
DOWNTOWN RENAISSANCE

Janet and Gerry Souter

ARCADIA

First Printed 2001.
Reprinted 2004.

Published by Arcadia Publishing,
an imprint of Tempus Publishing, Inc.
Charleston SC, Chicago, Portsmouth NH,
San Francisco

Printed in Great Britain.

Library of Congress Catalog Card Number: 2001090467

For all general information contact Arcadia Publishing at:
Telephone 843-853-2070
Fax 843-853-0044
E-Mail sales@arcadiapublishing.com

For customer service and orders:
Toll-Free 1-888-313-2665

Visit us on the internet at http://www.arcadiapublishing.com

In 1836, Asa Dunton first set foot on the Midwestern prairie that would one day become the thriving area now known as Chicago's northwest suburbs. Like so many pioneers who had come from the East or from Europe, he saw the rich soil and tall grass as a land that promised to be good to him. He settled in an area known as Deer Grove, just north and west of present day Arlington Heights. Though his sons, William and James, were still quite young, Asa purchased a plot of land for each of them. James farmed his plot, but William staked out a town that would stand the test of time. (Photo courtesy of National Archives.)

CONTENTS

ACKNOWLEDGMENTS

The writers wish to thank the following individuals and organizations that contributed their time, efforts, and materials to the production of this book:

Arlington Heights Historical Society
Arlene Mulder
Margo Stimely
Phil Theis
Joseph Freed & Associates
Eileen O. Daday
Mark Anderson
Mickey Wawrzyniak
Doug Mitchell
Arlington Heights Planning Commission—Charles Witherington Perkins
John Meinhardt
Flaherty Jewelers
Arlington Heights Chamber of Commerce
Management, 200 Arlington Place
Kristina Christie
Lauretta Haug
Dale Meyer
Arlington International Racecourse Ltd.

Introduction

The village that we know today as Arlington Heights began as a hodgepodge of mercantile and service ventures straddling the tracks of the Illinois and Wisconsin Railroad. The town's growth was the result of a shrewd visionary, William Dunton, who in 1852, persuaded the railroad to reroute its original plan to lay its tracks north and east of Dunton's land and to instead run it through his acreage. He had even deeded two strips of land each eight rods across for the railroad track.

At that time, the village was known as Dunton; prior to that, the little town had been called West Wheeling and Bradley. The last name might have stayed—it was the namesake of a Dunton friend—but a town downstate already held claim to "Bradley," so William Dunton christened the village after himself. Meanwhile, the railroad was running freight and passenger trains through the village, which boasted two grain elevators, cattle pens, two general stores, a hotel, a hardware store, a tin shop, a mill, and a cheese factory.

By 1874, Dunton's population had soared to over 600 souls. Many, including a few real estate agents, thought the name too rustic; the town needed a name with more distinction. After some deliberation, the town fathers settled on "Arlington Heights." Prospective homebuyers may not want to live in "Dunton," but they would have no problem telling people that they lived in "Arlington Heights."

During the late nineteenth century, the downtown businesses grew to such an extent that there was little the citizens lacked in goods and services. A cabinet maker, shoe store, druggist, barber, baker, general store, butcher, blacksmith, post office, and doctor were all clustered within the central business district. From 1880 on, Arlington Heights rushed to keep pace with changes that were taking place across the country. In 1887, the town was officially incorporated as a village. In 1892, a second railroad track and new depot were built. In 1897, the first phone lines in the village connected six people to each other.

During the early 1900s, the heart of the village continued to chug along the fast track toward the good life of the twentieth century. Electric lights were connected in 1910, new sewers completed in 1912, and ten miles of paved streets were dedicated to accommodate the increased use of automobiles in 1917.

World War I united village residents for the war effort. Arlington Heights sent 133 young men off to France. Citizens rallied and surpassed their quota in Liberty Bond drives, and they increased the amount of poultry raised to help feed America's soldiers.

Like other towns across the country, Arlington Heights enjoyed the prosperity and growth of the 1920s. This was especially evident in the downtown area, which received a few facelifts with the construction of the Reese and Roche buildings on Northwest Highway and the Engelking and Vail-Davis buildings south of the tracks. In 1927, on the far west side of town, the Arlington Park Racetrack was built on the site of a large cornfield. From then on, the

racetrack became the nationally recognized symbol of Arlington Heights.

The one-two punch of the Depression, followed by World War II, made the people of Arlington Heights realize that they could meet these challenges, survive, and continue to prosper. After the war, our population increased as subdivisions began to dot the outskirts of the village and beyond. During the 1940s and '50s, Arlington Heights was still primarily a farming community, and the center of town served its people well. Then the malls began to appear, luring shoppers and businessmen away from the merchants who knew everyone on a first-name basis.

In the 1960s, people with an eye on the future began to realize that if the downtown area was going to survive, it had to grow up—literally. However, not enough people were willing, or able, to take the giant step of tearing down and rebuilding. They could talk about it, and they could change an ordinance and allow structures to be built up to 90 feet tall. That was the first step. There were plans and visions, all stored in folders and in file cabinets; ideas were presented, discarded, and handed off to the next administration.

Finally in the 1980s, developers and the village board began taking the first step toward redefining the downtown. Stores had moved or gone out of business, and very few were replaced. Governing bodies knew that they needed a healthy number of residents to support any new retailers that moved into the area. The only way to go was up. Two high rises were constructed—one on either side of the tracks. A few years later, the rumblings began in earnest. Why not go all out? Overnight, it seemed the familiar downtown landscape changed, luxury apartments, shops, offices, a movie house, and a live performance center appeared. The creative use of funding, combined with the vision of men and women who saw beyond the present, made it happen. It is easy to say "no it won't work," or "they'll never go for it." However, it is another thing to take a deep breath and to actually do it. A master plan outlined in 1987 was expanded, and by 2000, three major mixed-use complexes catered to homeowners, shoppers, theatergoers, restaurant patrons, and businessmen. The downtown projects won several regional and national awards for design excellence.

In his wildest dreams, William Dunton could never have imagined this wide space beside an Indian trail would rise to receive national recognition and become a model for other communities.

One

DUNTON GETS
ITS START

Once William Dunton deeded a strip of land to the Illinois and Wisconsin Railroad for a right of way through his property, people looking for rich, cheap farmland and merchants seeing an opportunity to make a good living flocked to the little town by the tracks. They could not lose. Even then, the three important words were location, location, location. The town was just close enough to the culture of the big city, yet the healthy land surrounding it could produce a fine set of crops. The grasses and gently rolling hills could easily support cattle and dairy farming. Merchants saw a ready market for goods and services—travelers alighting from a dusty steam train needed a place to eat and drink. Farmers wanted a place close by to pick up supplies. Dunton—later Arlington Heights—had it all. Yankees, Germans, Scottish, Irish, and Scandinavians all worked together to build shops, schools, churches, and homes. They also kept pace with new inventions. In 1897, when they heard that a phone line nearby was set to bypass their village, they raised $400 to have a connecting line routed to their town. The twentieth century hovered in the wings, but Arlington Heights was ready.

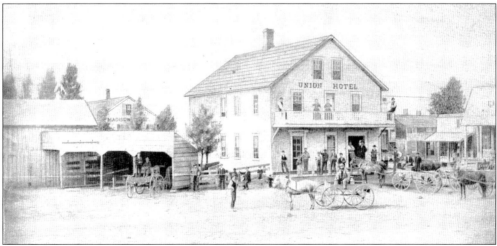

ARLINGTON HEIGHTS, 1860s. This is the first known image of Arlington Heights. At the time of this picture, the town was known as Dunton. The Union Hotel, on the south side of the railroad tracks, was at that location for another 100 years. To the right, and at right angles, is Myrtle Street, later changed to Dunton Avenue. (Photo courtesy of Arlington Heights Historical Society.)

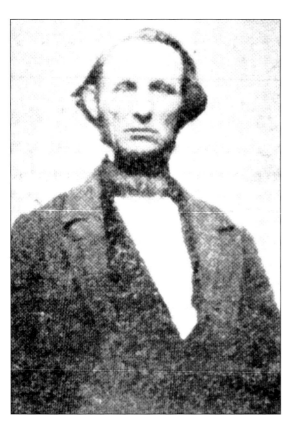

EARLY PORTRAIT OF WILLIAM DUNTON. In 1845, Dunton and his bride settled into a two-story clapboard house that sat beside an old Indian trail now known as Arlington Heights Road. Later, he persuaded the Illinois and Wisconsin Railroad to reroute their line so it crossed his property. He moved his home to make way for the tracks that would have gone through his living room. (Photo courtesy of Arlington Heights Historical Society.)

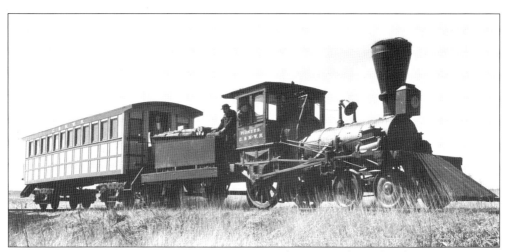

ORIGINAL 1848 PIONEER LOCOMOTIVE. Prior to the 1870s, the railroad's main source of income was freight. In 1857, a similar train operated between Dunton and Chicago on a schedule that was not designed for commuters. One train left downtown Dunton at 12:52 p.m., arriving in the city at 1:52 p.m. The return train left at 7:00 a.m., and, after several stops to pick up freight, pulled into Dunton at 9:00 p.m. (Photo courtesy of Chicago Historical Society.)

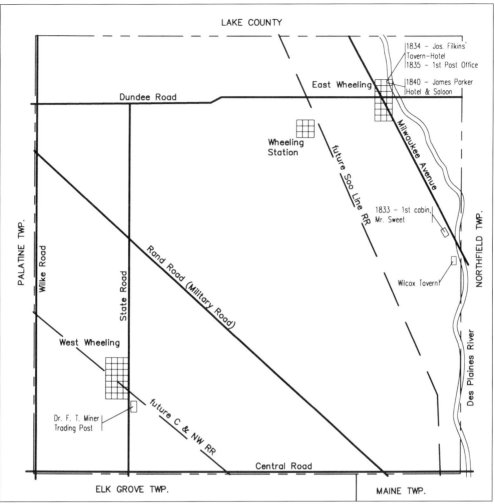

MAP OF WHEELING TOWNSHIP, EARLY 1850S. On the upper right is East Wheeling, the site of today's Wheeling, which is northeast of Arlington Heights. During the 1830s and '40s, settlers' cabins were scattered throughout various "groves" in what are now the northwest suburbs of Chicago. Other entrepreneurs opened taverns and trading posts along the main roads in the area. Joe Filkins' Tavern hotel and the first cabin were both built in 1833; the first post office in the township was established in 1835. Another hotel and saloon came in 1840. Originally, the Illinois and Wisconsin Railroad had planned to run its tracks along the Military, or Rand Road, but this map shows the line cutting through West Wheeling, as William Dunton's village was first called. Later it was known as Elk Grove Station, the name of the nearest post office. After the village acquired its own postal service in 1855, the name was changed to Dunton. State Road, on the east side of West Wheeling, is now Arlington Heights Road. (Map courtesy of Arlington Heights Historical Society.)

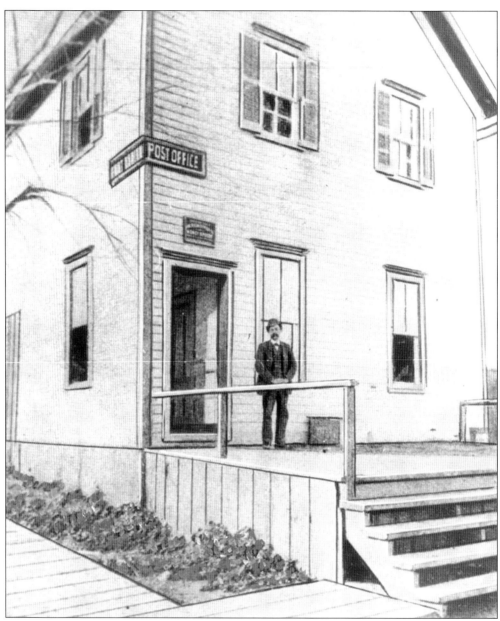

EARLY POST OFFICE. This post office was established on the triangle of today's Campbell and Davis Streets and Evergreen Avenue. The Union Hotel is just west of the building. Prior to this, mail had been delivered to the nearest post office in Elk Grove. In those days, postal carriers rode horseback, following old Indian trails. Often, before a town had an official post office, mail was taken to the postmaster's home or place of business. Once the town of Dunton was established along the route of the Illinois and Wisconsin Railroad, mail arrived by train. The baggage master would toss the mailbag as the train rolled through town. Mail to be sent was placed in a bag and hung on a crane that stood by the tracks. As the train came through, a mechanical arm protruding from the mail car snatched the bag. William Dunton's father, Asa, was the town's first postmaster. Shown here is Charles Sigwalt, postmaster, c. 1885. Bank One now occupies this site. (Photo courtesy of Arlington Heights Historical Society.)

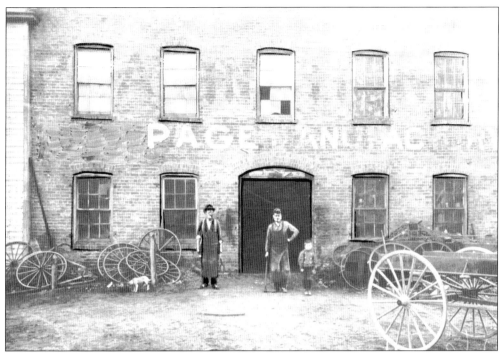

BLACKSMITH, WAGON, AND CARRIAGE SHOP. Mr. Page established this shop at what is now 13 West Davis Street in 1855. John Fleming operated a similar establishment at 15 West Campbell Street. Blacksmith and carriage shops were kept busy until the early 1900s. A farmer or villager had to keep his horses healthy and buggies in good repair for hauling and transportation. (Photo courtesy of Arlington Heights Historical Society.)

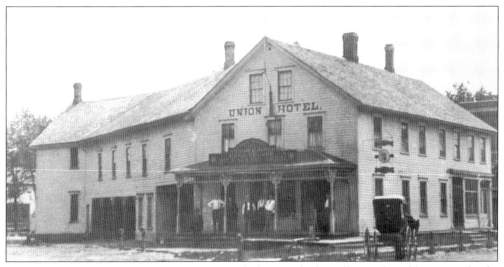

UNION HOTEL. This establishment prospered along with the village. The addition on the far left is the post office seen on page 12. On the left is the horse stable, now attached to the building, as part of the addition. Note the covered porch that replaced the balcony seen in the earlier photograph. (Photo courtesy of Arlington Heights Historical Society.)

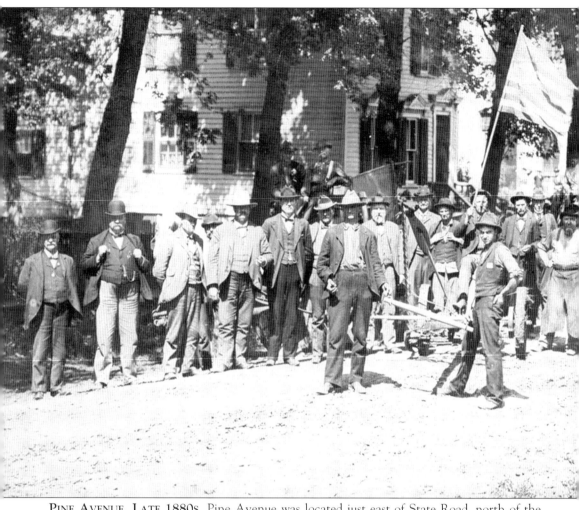

Pine Avenue, Late 1880s. Pine Avenue was located just east of State Road, north of the railroad tracks. Wooden sidewalks made it easier for people to navigate, but after a rain or heavy snow, the muddy streets slowed carriage traffic to a virtual standstill. A village ordinance required all able-bodied men between the ages of 21 and 50 to spend at least two days per year on road maintenance and alley construction. Residents were required to construct sidewalks of

2-inch planks. Most homes and stores had boot scrapers on the front stoop. Another law stated that no one tie a horse to a railing or other structure without the express consent of the owner. One can only hope that these men are engaged in some sort of public works improvement project. (Photo courtesy of Arlington Heights Historical Society.)

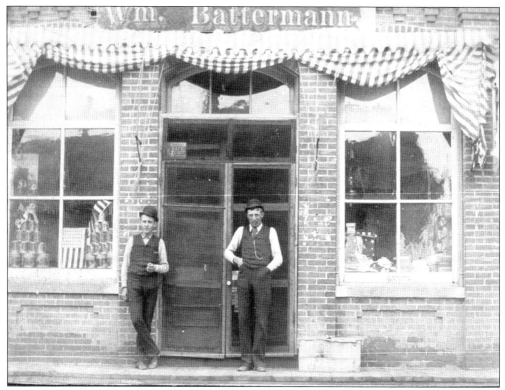

BATTERMAN'S HARDWARE. The Batterman Building was located at 105 East Davis Street. William Batterman served as postmaster from 1893 to 1897. The post-Civil War era was a period of tremendous growth in the area around the tracks. Judging from the flags displayed in the window, it appears that the Fourth of July is not far away. (Photo courtesy of Arlington Heights Historical Society.)

FIRST RAILROAD STATION IN DUNTON. This station, built in 1854, served as a depot until 1892, when another track was laid and a new station constructed. It originally stood between Evergreen Avenue and Dunton Avenue on the south side of the track. When the new passenger depot was built, the 1854 building was moved west between Dunton Avenue and Vail Avenue and used as a freight station. (Photo courtesy of Arlington Heights Historical Society.)

16

WILLIAM BEAUMONT AND JOHN PROCTOR.
These eager young men were typical of the
ambitious and hard-working businessmen
who saw Arlington Heights as a good place
to make an honest living in the late 1880s.
New homes were being built, attracting city
dwellers to the clean air of the suburbs, and
there was plenty of work to keep them busy.
(Photo courtesy of Arlington Heights
Historical Society.)

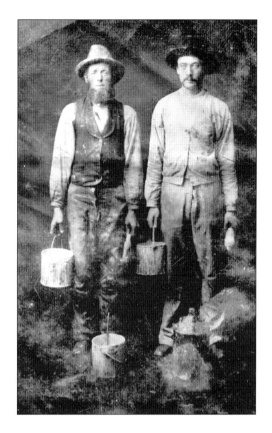

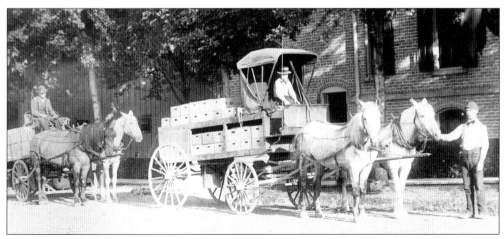

WILLIAM MULLER MAKING A DELIVERY OF HIS FAMOUS SODA, c. 1890. Starting in the 1882,
William's father, Frederick, operated his business north of town on Fremont Street in a two-
story structure, with the plant on the first floor and living quarters on the second. He made
several trips to Chicago for supplies and rode many miles to deliver to Wheeling, Half Day,
Schaumburg, and Itasca. (Photo courtesy of Arlington Heights Historical Society.)

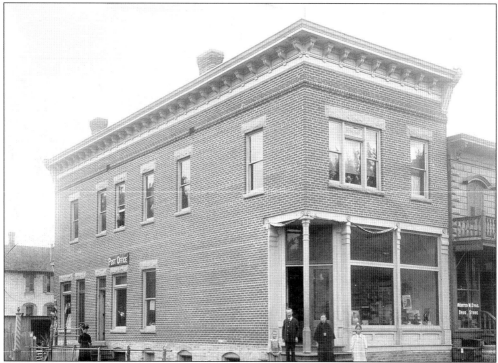

BOLTE SHOE STORE. Henry Bolte erected this brick building on the southwest corner of Campbell Street and Dunton Avenue in 1897, replacing a frame structure that also housed a shoe store. In 1901, it became a bank, and later the corner was home to a realty office, a drug store, and a restaurant. Today it is simply an empty lot with greenery and benches for "downtowners." (Photo courtesy of Arlington Heights Historical Society.)

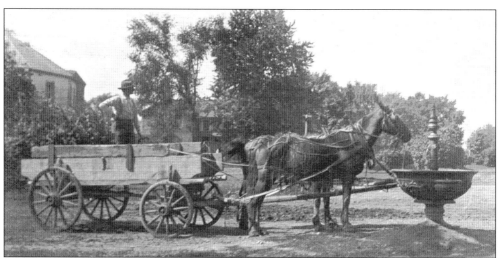

DOBBIN GETS A DRINK. Anyone who wanted the privilege of watering his horse at the public fountain paid $2 for a subscriber certificate to cover the maintenance cost. Before shopping, the townspeople and farmers would give their horses a drink. This fountain was possibly located at the intersection of Davis Street and Dunton Avenue. (Photo courtesy of Arlington Heights Historical Society.)

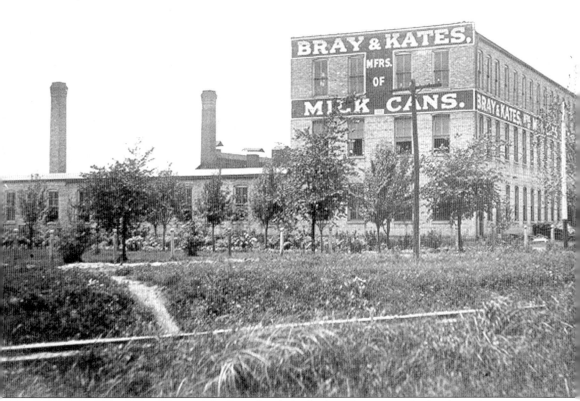

BRAY AND KATES MILK CANS. The Bray family had a long history in the hardware business. John Bray and Benjamin Kinder operated a hardware store at 8 North Dunton Avenue from 1869 to 1872. John's brother, Joseph, ran the store until he passed away in 1877. Richard, his nephew, continued the operation until 1881. For the next nine years, John Burkitt owned the store and sold jewelry as well as hardware. After traveling the country working as tinsmiths, Richard Bray and his close friend, Anthony Kates, returned to Arlington Heights in 1890. Finding Burkitt's location available, they reestablished the family hardware business, but also assembled milk cans in the back of the store. The milk can business grew rapidly, forcing them to build a three-story frame structure at 11 West Davis Street. When the business expanded again, the company constructed this factory, south of the railroad tracks in 1897, at what is now Ridge Avenue. (Photo courtesy of Arlington Heights Historical Society.)

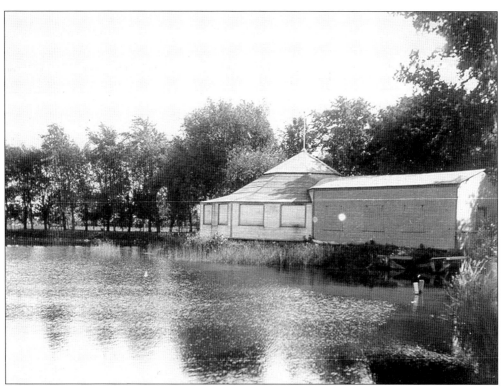

MEYER'S POND. In 1883, Henry Meyer and two other businessmen created this pond after damming outlet creeks in the area. Then they built a beer garden and dance pavilion. In the winter, blocks of ice were cut and stored in the icehouse for use in the summer. Located south of the railroad tracks and east of State Road, the pond was the gathering place for summer picnics and winter skating until 1934. (Photo courtesy of Arlington Heights Historical Society.)

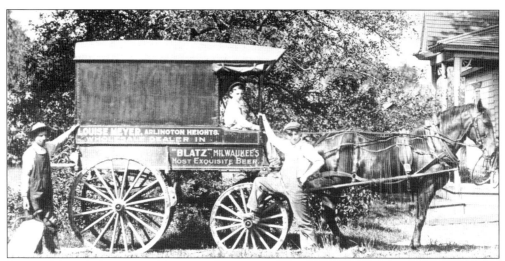

LOUISE MEYER'S DELIVERY WAGON. The Meyers knew people would get thirsty at all those picnics and dances, so they made certain that there was always plenty to drink. Meyer was a wholesale Blatz Beer distributor. The railroad even had a spur line running east of State Road to Meyer's unloading platform. (Photo courtesy of Arlington Heights Historical Society.)

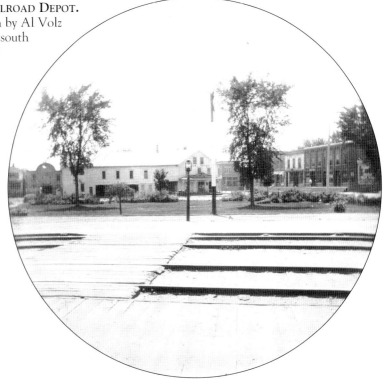

VIEW FROM THE RAILROAD DEPOT. This photo was taken by Al Volz about 1895. Looking south from the tracks is the Union Hotel on the block of what is now Dunton Avenue, Campbell, and Davis Streets. To the right are buildings in the business district. By this time, a second track had been laid. (Photo courtesy of Arlington Heights Historical Society.)

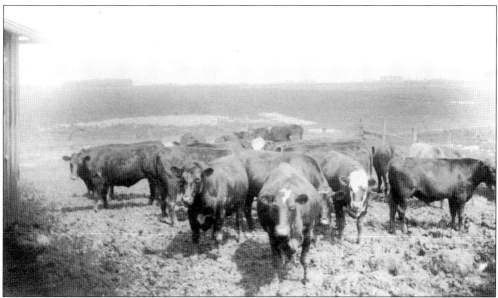

COW PENS. The farmers in the area herded their cattle into town and kept the animals in holding pens near the train station during the night. The livestock were boarded on the 4:00 a.m. train the next day, bound for Chicago's stockyards. It was said that the stockmen left salt licks in the pens, forcing the cattle to drink water on arrival, thus increasing their sale weight. However, the townspeople did not appreciate the cows' bellowing far into the night. (Photo courtesy of Arlington Heights Historical Society.)

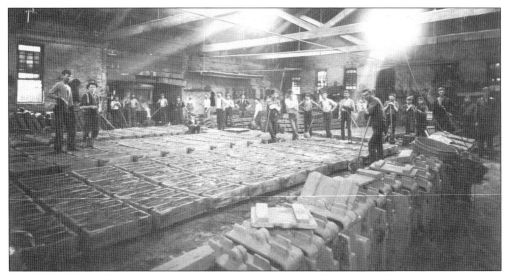

INTERIOR OF THE SIGWALT SEWING MACHINE COMPANY FOUNDRY. The Sigwalt Company, manufacturers of cast-metal treads and stands for Singer sewing machines, was located on Foundry Road (now Kensington Road), about two blocks east and north of State Road and the railroad tracks. In 1883, the company was sold to the Diamond Sewing Machine Company. (Photo courtesy of Arlington Heights Historical Society.)

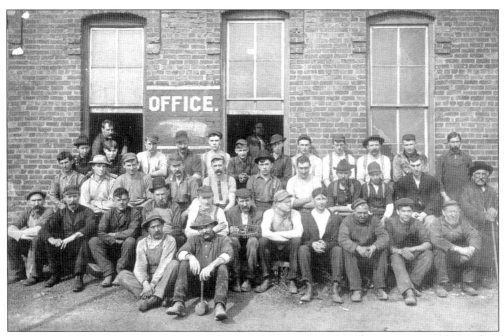

EMPLOYEES OF THE DIAMOND SEWING MACHINE COMPANY. This photo was most likely taken prior to the fire, which destroyed the foundry in 1895. The original foundry business was relocated from Chicago to Arlington Heights, thanks in part to the villagers who contributed $11,000 to help build the factory. (Photo courtesy of Arlington Heights Historical Society.)

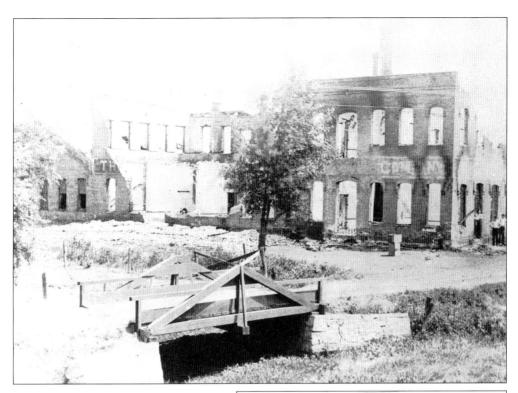

FOUNDRY SHORTLY AFTER THE FIRE, 1895. James Harris purchased the ruins and reconstructed the building for the purpose of manufacturing gray iron castings and sewing machine standards. When he died six years later, his brother-in-law, George Peter, took over the company, partnered with Albert F. Volz, and expanded their manufacturing line to include school desk and opera seat standards. (Photo courtesy of Arlington Heights Historical Society.)

AMERICAN HOUSE TAVERN. This tavern, built in 1899 at 33 West Campbell Street, was known as the Vail Tavern from 1917 to 1932. The large German population looked on beer and wine as part of their daily life, so saloons never lacked for patrons. The Yankees in town, many of whom were against alcohol of any kind, continually fought to have liquor and beer outlawed, but failed until the passage of the 18th Amendment. (Photo courtesy of Arlington Heights Historical Society.)

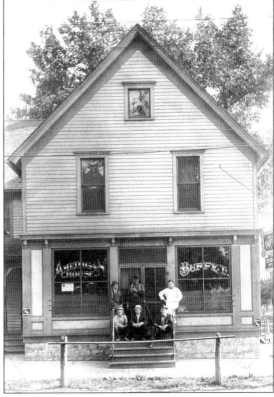

23

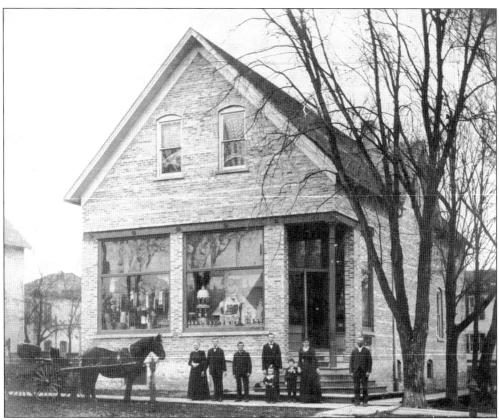

REDEKER STORE, c. 1893. Located at the northeast corner of Vail Avenue and Campbell Streets, this building has been a grocery store and pool hall, and it still thrives today as a casual dining restaurant. The Redekers were part of a wave of German immigrants that came to the town in the decades following the Civil War. Prior to that, New England and British citizens made up the bulk of Dunton's population. Some townspeople railed against this German invasion and perhaps felt threatened by it. Other citizens, seeing a way to make a profit, sold land to the newcomers at a price far exceeding the actual value of the property. Still, the Germans were an ambitious and hard-working people, and as a shopkeeper named Olmsted said, "I would rather take the promise of one of these German immigrants than the note of a lot of your Americans." (Photo courtesy of Arlington Heights Historical Society.)

Two

Now We're Arlington Heights

The first ten years of the twentieth century brought a toy box full of fascinating inventions. Electricity, the automobile, and the airplane brought people into a brand new world. None of this was lost on the Midwestern village by the railroad tracks. By 1917, Arlington Heights enjoyed the same conveniences as city dwellers. Roads and sidewalks now kept its citizens out of the muck and mud—at least until they were past the center of town in their new automobiles. The lamplighter who turned on the gas-powered streetlights each night found himself unemployed after electric lights were installed. The town now had two banks to service businesses and homeowners. When World War I began, the villagers rallied to support the country and surpassed their quota in Liberty Bond drives. Through all of this, there was just enough light industry in the village to keep it economically viable. The Muller Pop Factory, the Peter and Volz Company, manufacturers of sewing machine castings, and Bray and Kates were all located just on the edge of town—close enough for the convenience of their employees, yet not close enough to disturb the peacefulness of the villagers.

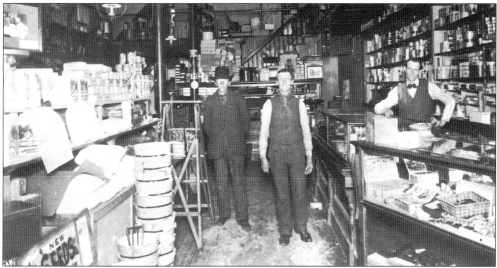

INTERIOR OF REDEKER STORE c. 1900. Not exactly the same as the wide aisles and multiple choices of today's supermarkets, this store was just enough to supply the basic needs of a local family in the early twentieth century. From left to right are: William Luth of Elk Grove; Frederick Redeker Sr., and Frederick Redeker Jr. (Photo courtesy of Arlington Heights Historical Society.)

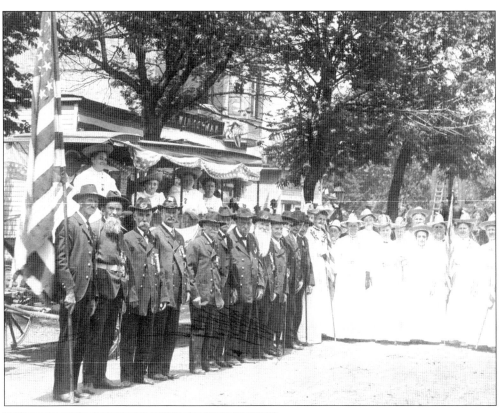

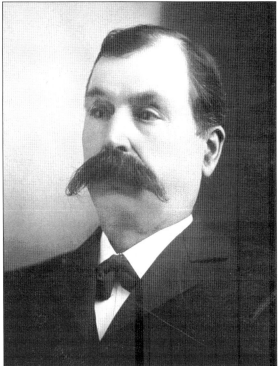

CIVIL WAR REUNION. The village made its quota of 61 in providing soldiers for the Union Army during the Civil War. Filled with patriotic fervor, the able-bodied men marched to the train station or rode horseback into Chicago. Some even walked down Rand Road toward the city. Two of Dunton's citizens died in battle. (Photo courtesy of Arlington Heights Historical Society.)

CHARLES SIGWALT. A man who played a pivotal role in the growth of the village, Sigwalt settled in Dunton at the age of 22, and shortly thereafter went off to fight in the Civil War. After he returned, he lived out his life as a successful businessman, postmaster, village clerk, village board president, and mayor. He died in 1930, at the age of 86. (Photo courtesy of Arlington Heights Historical Society.)

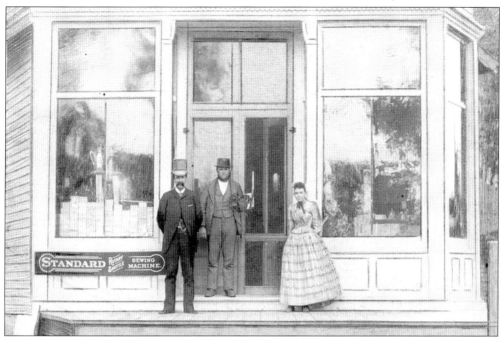

JOHN BURKITT STORE, 1891–1918. This store, located at 111 East Davis Street, served as the telephone exchange as well as the offices of the *Arlington Review*, one of the first newspapers in the village. During his lifetime, Burkitt was a jeweler, maintained a cherry orchard, sold automobiles, managed the telephone exchange, and also sold windmills. (Photo courtesy of Arlington Heights Historical Society.)

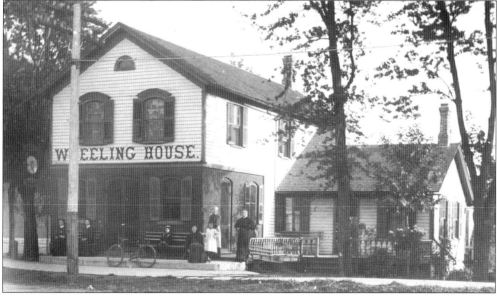

WHEELING HOUSE, c. 1900. This tavern hotel was built by Stephen Briggs in 1855. Conveniently located at the corner of Evergreen Avenue and Campbell Street near the train depot, it offered food and lodging for the salesmen who came through town on their way to Chicago. It later became the Lauterberg Tavern. (Photo courtesy of Arlington Heights Historical Society.)

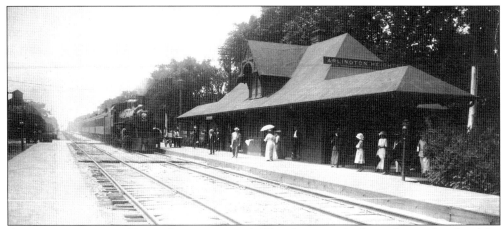

ARLINGTON HEIGHTS TRAIN STATION, 1915. This depot was built on the north side of the track in 1892, shortly after the second rail track was laid. These people are joining the growing number of commuters making their way into the city. The new station also boasted wide parkways for buggies to unload on either side of the tracks. (Photo courtesy of Arlington Heights Historical Society.)

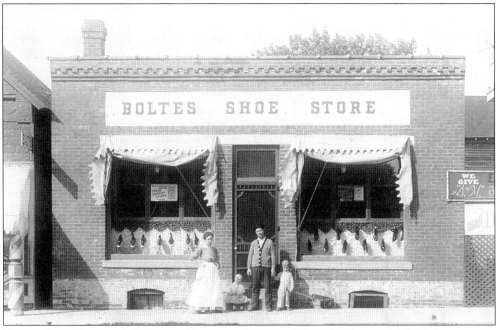

BOLTE SHOE STORE, 6–8 SOUTH DUNTON AVENUE. Edward Bolte established this store in 1903. By this time, the citizens could enjoy a shopping trip into town without the messy struggle of navigating muddy streets. Prior to street regrading in 1903, Dunton Avenue had been known as "Canal Street," because of the splashing of water and dirt from carriage wheels. (Photo courtesy of Arlington Heights Historical Society.)

PART OF THE "BRICK BLOCK," 2 NORTH DUNTON AVENUE, 1903. In 1874, after a fire destroyed frame buildings on Dunton Avenue between Campbell and Davis Streets, brick structures were built. Because of frequent flooding from inadequate drainage, the buildings were raised about 4 feet in 1893, and wooden platforms were built. Iron stairways and rails, shown here, replaced the platforms in 1904. Floors were lowered in 1917, after paved streets were installed. (Photo courtesy of Arlington Heights Historical Society.)

SCHIFFMAN AND RAU STORE, c. 1916. This store was located on the south side of Campbell Street between Dunton and Vail Avenues, down the street from the Wheeling House and around the corner from the brick block. In the 1920s, frame buildings on that block were razed and replaced by a row of two-story brick buildings. (Photo courtesy of Arlington Heights Historical Society.)

GIESEKE'S DEPARTMENT STORE, c. 1915. Gieske's is located at 103 East Davis Street. Looking farther down are Nehi's Drug Store (site of the first telephone toll station in 1897), Helm's Ice Cream Shop, Burkitt's Jewelry Store, and Reese's Livery stable. Gieseke's store was the mainstay of the village for over 50 years. (Arlington Heights Historical Society.)

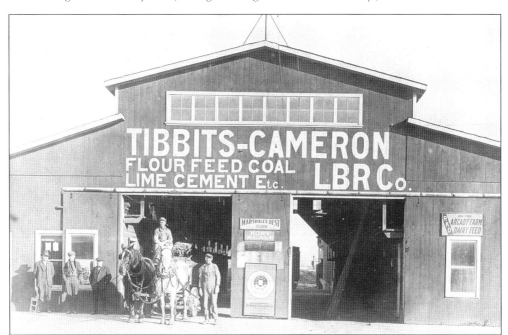

TIBBETS-CAMERON LUMBER COMPANY, STATE ROAD, c. 1910. Tibbets Cameron had its own spur railroad siding to bring coal onto their property. In the early 1930s, when railroad transport began to decline, the spur rejoined the rest of the track leading into the city. (Photo courtesy of Arlington Heights Historical Society.)

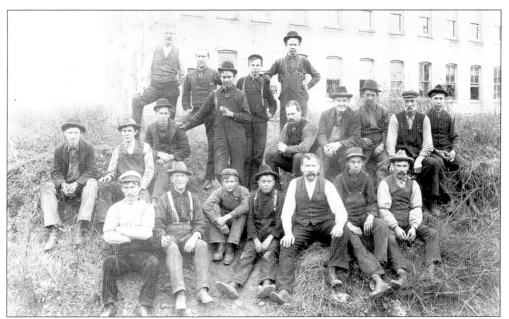

EMPLOYEES OF THE BRAY & KATES MANUFACTURING COMPANY, 1905. A number of the Bray & Kates workers were immigrants, fresh from Eastern European countries. Others went to work for the company right out of high school, so it became known as "Arlington University." Because the wages were so low, only single men could afford to work in manufacturing. (Photo courtesy of Arlington Heights Historical Society.)

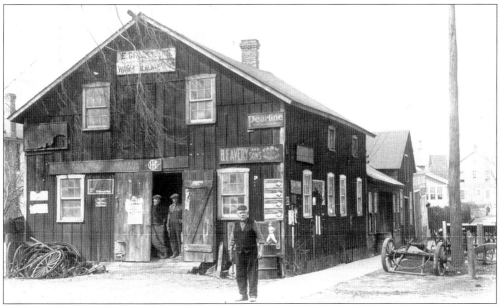

ED GREENBERG CARRIAGE AND BLACKSMITH SHOP. One of the many blacksmith shops in town, this was located on the northwest corner of Evergreen Avenue and Mors Parkway (later Northwest Highway), from 1872 to 1924. In 1925, Greenberg moved the building to the lot just to the north and used it as a machine repair shop. A two-story building was constructed on the original site. (Photo courtesy of Arlington Heights Historical Society.)

JOHN BOEGER CARPENTER SHOP AND LUMBER YARD. John Boeger operated this shop at 113 South Vail Avenue, beginning in 1901. He built a bandstand for the town in 1917, at the triangle formed by Vail Avenue, Wing Street, and the railroad tracks. In 1910, he had already begun replacing his wooden sidewalk with cement ones prior to a public notice that forced all businesses to install cement walks. (Photo courtesy of Arlington Heights Historical Society.)

EMIL SIGWALT AND EDWIN MEYER AT MEYER POND. Most likely, Edwin Meyer was not related to Henry Meyer, who created the pond and park. There were so many Meyers in Arlington Heights that they were given nicknames according to their occupation. As a result, men were known as "Carpenter Meyer," "Egg Meyer," "Butcher Meyer," etc. (Photo courtesy of Arlington Heights Historical Society.)

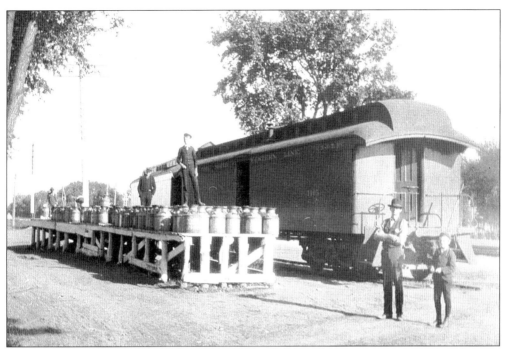

NORTH SIDE OF RAILROAD TRACK, EARLY 1900S. This siding, east of the new depot built in 1892, was called the "milk switch." In the morning, farmers would leave their milk cans for pickup by the milk train from Wisconsin. At the end of the day, they picked up their empty cans. (Photo courtesy of Arlington Heights Historical Society.).

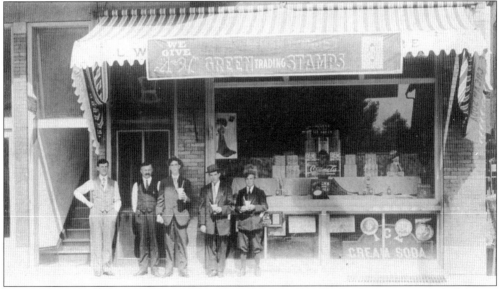

L.W. HANNEMAN DRUG STORE. Hanneman operated this store at 10 West Campbell Street from 1908 to 1916. Even then, the offer of Green Stamps was used to lure customers into buying more. They are, from left to right: L.W. Hanneman, unidentified, Merle Guild (who later fought in World War I), Henry Kennicott, and Harvey Winkleman. (Photo courtesy of Arlington Heights Historical Society.)

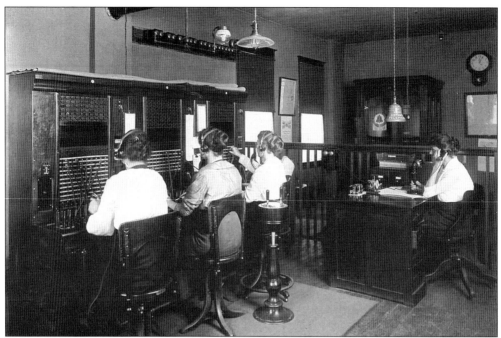

TELEPHONE EXCHANGE. It didn't take long for the telephone to catch on in the village. In 1909, when the Burkitt Store phone station became too small, it was moved to this exchange on the upper floor at 12 West Campbell Street and operated there until 1929. Still, the subscribers could not be sure that their conversations were private. Phones in town operated on four-party lines, later on two-party. (Photo courtesy of Arlington Heights Historical Society.)

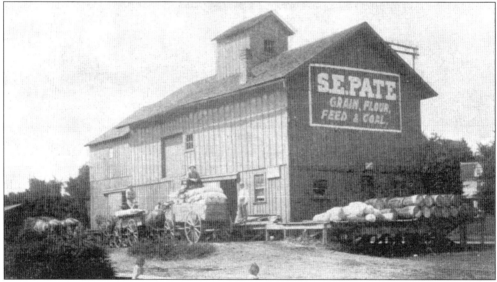

S.E. PATE GRAIN ELEVATOR. This was the original Peter and Tewksbury grain elevator at Vail Avenue, south of the railroad tracks. It was used primarily for grain storage and survived several ownerships before Sherman Pate purchased it 1894. Later, he saw a growing need for coal and fuel oil and expanded his operation to offer those products. (Photo courtesy of Arlington Heights Historical Society.)

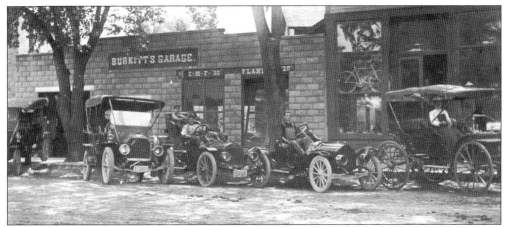

J.W. Burkitt Garage and Store. Burkitt saw an opportunity to make money on a burgeoning industry and opened the first commercial garage at 113 East Davis Street in 1910. He ordered ten automobiles from Studebaker, five of which were "Flanders," and the other five "E.M.F.," which stood for "Everett, Melger, and Flanders." However, owners of the E.M.F., after dealing with the auto's numerous mechanical problems, felt that a more appropriate name was "Every Morning Fix." (Photo courtesy of Arlington Heights Historical Society.)

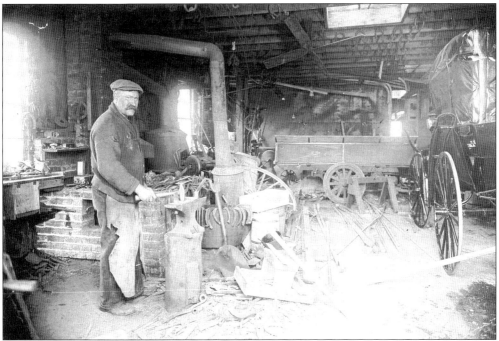

Andrew G. Horcher Blacksmith Shop. Horcher operated this shop at 22 South Evergreen Avenue until it became evident that the "horseless carriage" was here to stay. In 1922, he retooled and became an auto dealer, as did so many other blacksmiths. His product line was the Graham Paige auto. Horcher had operated his businesses in various locations over the years. Some people commented that he should "put his shop on wheels." (Photo courtesy of Arlington Heights Historical Society.)

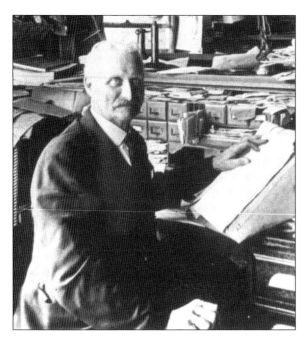

HOSEA C. PADDOCK. The founder of Paddock Publications got started in the newspaper business in 1883, when he bought the *Wheaton Illinoisan*. Five years later, he sold the publication and purchased newspapers in Waukegan and Libertyville. Eventually, he acquired the Palatine *Enterprise* and the *Cook County Herald* for $275. His motto, which still appears on the *Herald* editorial page today, was "Our Aim: To fear God, tell the truth, and make money." (Photo courtesy of Arlington Heights Historical Society.)

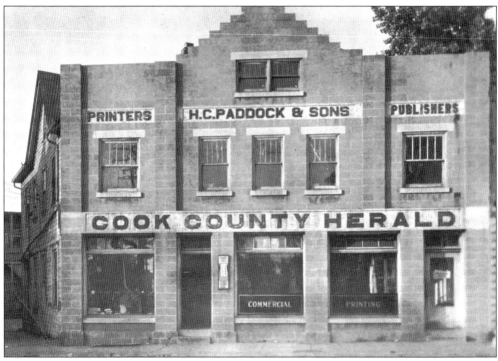

COOK COUNTY HERALD BUILDING, 1904–1939. Hosea C. Paddock purchased The *Cook County Herald* from George Bugbee in 1899. In 1904, he bought this building at 9 West Davis Street to house his printing press. Prior to that, he had carried the hand-set type into Chicago for printing. The *Cook County Herald* became the *Arlington Heights Herald* in 1926. Paddock Publications and the *Herald* still thrive today under the Paddock family's leadership. (Photo courtesy of Arlington Heights Historical Society.)

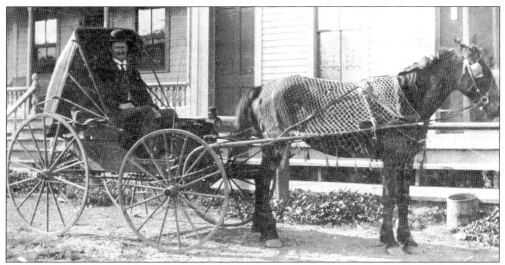

H.C. Paddock and His Horse "Bonnie." It wasn't enough to have a newspaper operation. Paddock also needed subscribers. He and Bonnie combed the countryside looking for readers. It was said that Paddock would stand in the field and not let the farmer get back to work until he bought a subscription. (Photo courtesy of Arlington Heights Historical Society.)

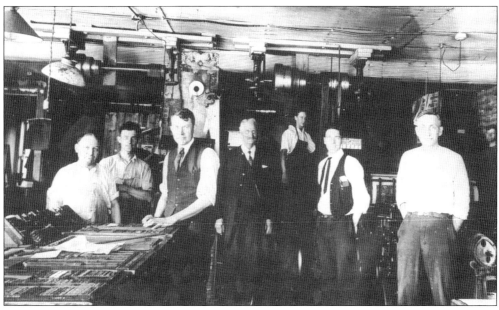

Paddock Employees, early 1900s. The gasoline engine that powered the printing press was so noisy that neighbors complained they couldn't sleep when it operated during the night. During the 1900s, half the paper was printed in English and half in German, to accommodate the heavy German population. (Photo courtesy of Arlington Heights Historical Society.)

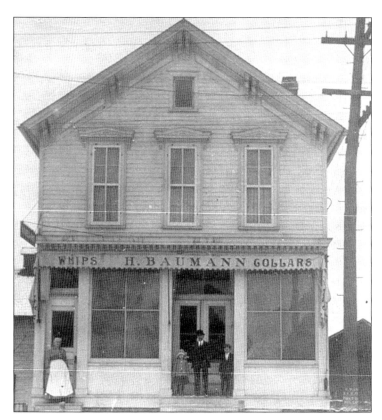

BAUMANN WHIPS AND COLLARS. Henry Behlendorf constructed this building at 9 South Dunton Avenue in 1874, and operated a grocery store there until 1881. E.M. Thomas owned a drug store in part of the building. Baumanns did business here from 1905 to 1913, about the time the automobile took over. This was also the site of, among other things, a grocery, hardware, jewelry store, tailor shop, tavern, and wallpaper store. (Photo courtesy of Arlington Heights Historical Society.)

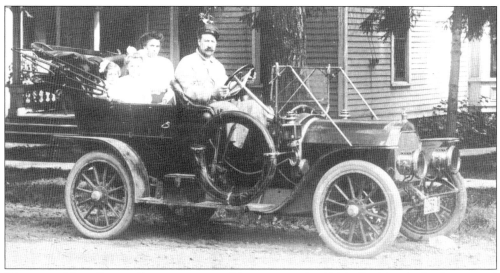

MR. AND MRS. LOUIS ROEHLER WITH NEIGHBORS. In 1913, Roehler built the second commercial garage in town at 304 North Evergreen Avenue and was the first "Tin Lizzie" dealer in the area. His Fords sold for $490, but he had sold so many that year that he later offered a discount of $50 to all who had purchased his autos. Here he is showing off the 1913 model. (Photo courtesy of Arlington Heights Historical Society.)

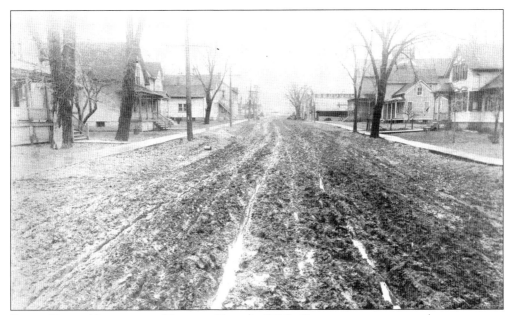

STATE ROAD (ARLINGTON HEIGHTS ROAD), 1916. Cement streets were only a year or so away when this picture was taken. Beginning in 1913, county roads were covered with gravel and crushed stone and graded higher for drainage. By 1916, that was not enough, so Arlington Heights instituted its own project, and during the next four years, Arlington Heights, Central, and Rand Roads were paved. (Photo courtesy of Arlington Heights Historical Society.)

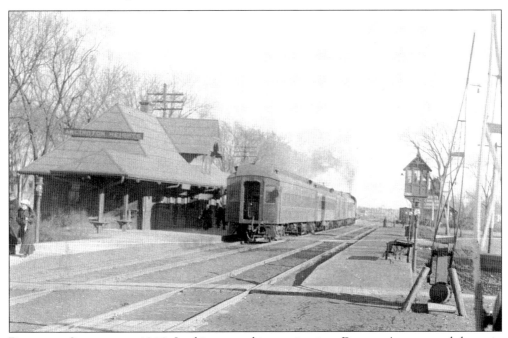

RAILROAD STATION, c. 1912. Looking east, this crossing is at Dunton Avenue, and the train is headed toward Chicago. The gate tower near Evergreen Avenue controls the crossing gate, located in the background to the right. The gates were operated by hydraulics and had to be hand pumped to bring them down. (Photo courtesy of Arlington Heights Historical Society.)

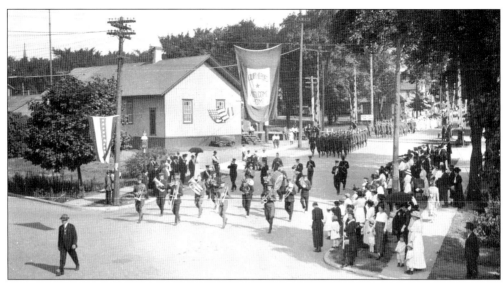

Victory Parade at the End of World War I. These World War I veterans are marching north on Dunton Avenue on September 6, 1919. A picnic at the school playground is waiting for them. The parade included the Arlington Heights marching band, decorated autos, bells, and a great deal of cheering and speeches. (Photo courtesy of Arlington Heights Historical Society.)

Merle Guild. The American Legion Post 208 is named after this World War I veteran. Before the war, he had served in the Arlington Heights Fife and Drum Corps. During the summer, the corps earned passage on excursion boats to Michigan by playing for a half hour before the boat left and again on the return trip. (Photo courtesy of Arlington Heights Historical Society.)

Three

A RACETRACK AND A HIGHWAY

The unbridled optimism of the 1920s gave developers and entrepreneurs all the encouragement they needed to construct, spend, and construct some more. Yet these were not just haphazard plans they made. Quality and style were uppermost in the minds of the city planners as well as builders. Architects catered toward people's preference for the Tudor style, heavily in vogue at the time. Homes in the prestigious Scarsdale area just south of downtown featured brick facades, arched doorways and windows, and wooden beams. The new Vail-Davis Building, as well as those on the north side of the railroad tracks, had similar details. But the villagers had other concerns during this period, namely, how to get around the Volstead Act, the federal law prohibiting the sale of liquor. Beer-loving Germans found ways of manufacturing their own brews. Some establishments installed slot machines, and a piece of that action was used to enhance the village treasury when it suffered the loss of revenue from liquor sales. The village board also required licenses for all businesses to make up for the shortfall. This increase may have been passed on to the consumer, but no one seemed to mind. Prosperity reigned.

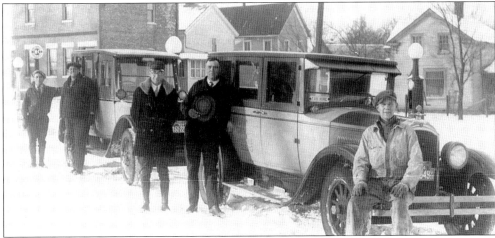

WILLIAM METZ TAXI SERVICE This photo was taken at the corner of State Road and Northwest Highway. The Sterling Oil Company is in the background to the left. The home on the far right was William Dunton's first home—the one that had been in the way of the railroad tracks in 1854, and was moved to the location shown here, before being moved to a site on Hintz Road several miles north. It was torn down in the 1960s. (Photo courtesy of Arlington Heights Historical Society.)

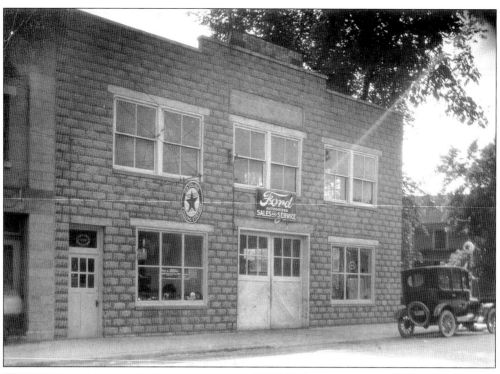

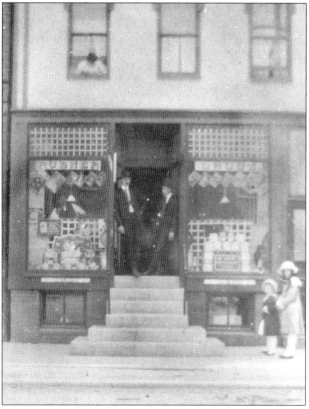

WETTERMAN'S FORD GARAGE. The Wetterman garage was operated at 13 West Davis Street from 1919 to 1926. It had been purchased from Charles Peterson, a former dealer in buggies and blacksmithing before the onslaught of the "horseless carriage." By the end of World War I, the auto had taken over, but the last blacksmith holdout did not pull up stakes until 1927. (Photo courtesy of Arlington Heights Historical Society.)

RUBNER DRUG STORE. Doctor Dyas was the original owner of this drug store at 3 West Campbell Avenue from 1882 to 1914. John Rubner took over in 1914, and operated it until 1942. The building was empty for the next two years until Ed Christen opened a delicatessen store, which lasted until 1956. (Photo courtesy of Arlington Heights Historical Society.)

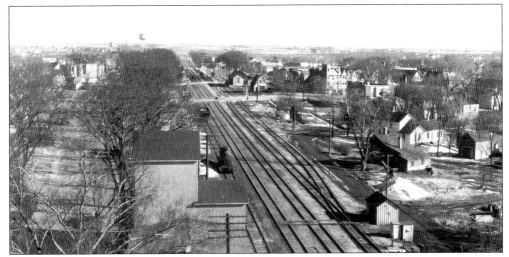

TWO TRACK RAILROAD LINE, c. 1929. This view is looking eastward from Highland Avenue toward downtown Arlington Heights. The siding at the left was used for cattle pens and grain elevators. This is most likely just prior to the building of Northwest Highway, which was completed in 1928. (Photo courtesy of Arlington Heights Historical Society.)

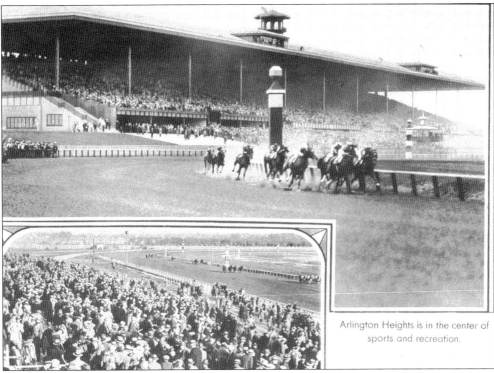

Arlington Heights is in the center of sports and recreation.

ARLINGTON PARK ADVERTISEMENT. The sport of kings came to Arlington Heights in 1927, in conjunction with the construction of Northwest Highway, which led motorists to the racetrack. Although the track was located west of the downtown area, it had a marked effect on the economy and tax base of the village. The railroad opened a station there as well, to make it easy for city dwellers to part with their money. (Photo courtesy of Arlington Heights Historical Society.)

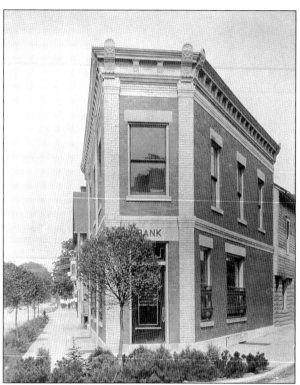

PEOPLES STATE BANK. Local merchants and businessmen organized this bank, located at Campbell and Davis Streets and Evergreen Avenue, in 1911. In 1926, the Women's Club requested use of the upstairs to house books for the Arlington Heights Community Library, since the original library had grown too small for its collection. The bank was forced to close in 1932, at the height of the Depression. It reopened as the Arlington Heights National Bank in 1937. (Photo courtesy of Arlington Heights Historical Society.)

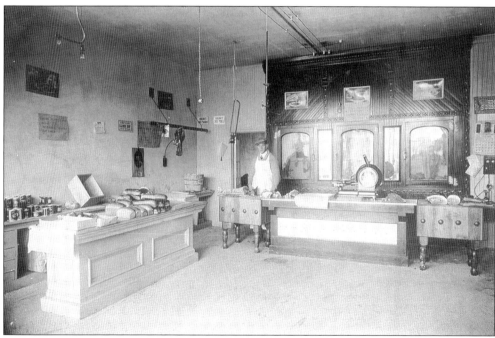

ROBERT MALZAHN MEAT MARKET, c. 1921. This store was located at 7 South Dunton. It was housed in a frame building, although in the mid-1920s, brick buildings were being constructed all around it. Note the butcher block tables, then used by butchers and are now seen in many modern homes. (Photo courtesy of Arlington Heights Historical Society.)

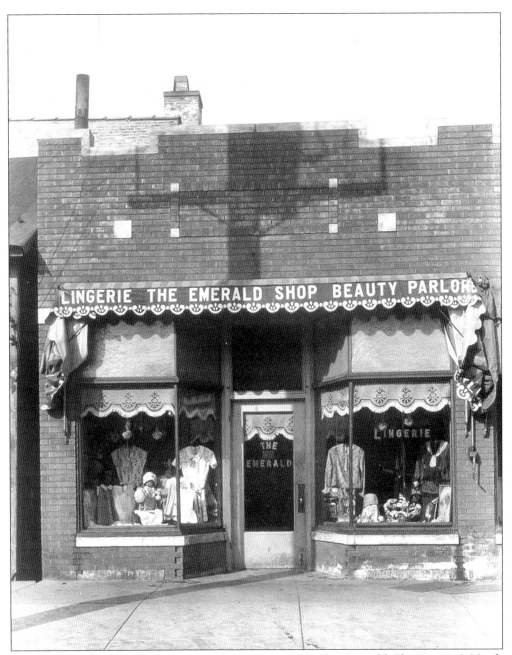

EMERALD SHOP. This photo was taken prior to 1931. The Emerald Shop, at 112 North Evergreen, seems to have offered many services. Businesses on the north side of the tracks were related to other interests. They included a roller mill, a creamery, and a movie house (Photo courtesy of Arlington Heights Historical Society.)

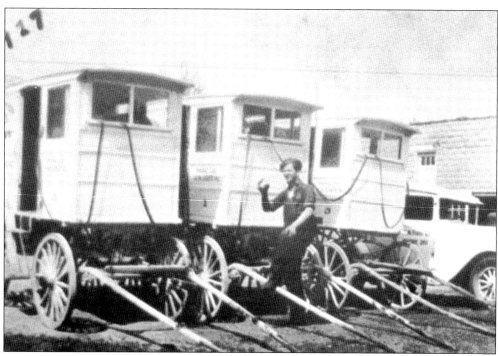

KNAACK DAIRY, 1927. The dairy was located on Evergreen Avenue. The construction of new homes in the area, especially in Scarsdale, south of town, kept dairies busy with all the new families. (Photo courtesy of Arlington Heights Historical Society.)

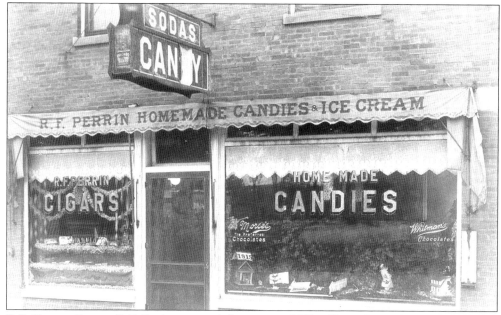

R.F. PERRIN STORE. R.F. Perrin operated this store at 3 West Davis Street from 1921 to 1927. The building next door at 7 West Davis Street became the headquarters of the newly formed Arlington Heights Businessmen's Association, established in 1924 to trade information and to discuss common concerns. (Photo courtesy of Arlington Heights Historical Society.)

46

REDEKER REAL ESTATE. As part of the 1920s building boom, this structure was erected at Dunton Avenue and the newly constructed Northwest Highway in 1925. By this time, Arlington Heights also had a slogan—the result of a contest held in 1921. It was, and still is, known as the "City of Good Neighbors." (Photo courtesy of Arlington Heights Historical Society.)

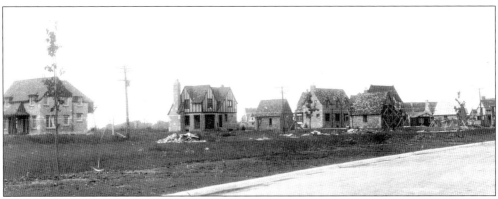

HOME CONSTRUCTION, c. 1930. The areas near the center of town became the site of a strong growth in residential construction in the late 1920s, thus contributing to the viability of the business district. Most lots sold for $1,990 to $3,000, a hefty price for that period. (Photo courtesy of Arlington Heights Historical Society.)

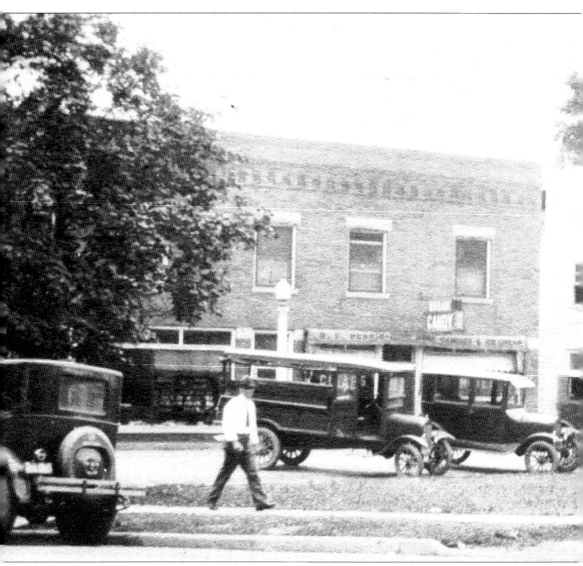

DAVIS STREET, EARLY 1920S. With the widening of Northwest Highway, many businessmen decided it was time to replace frame buildings with brick structures, with entrances to businesses now at ground level. A few already existed on Davis Street. During the 1920s, new buildings sprang up on both sides of the tracks, including: a six-store unit at Miner Street and Evergreen Avenue on the north side of Northwest Highway, the Arlington Heights State Bank on North

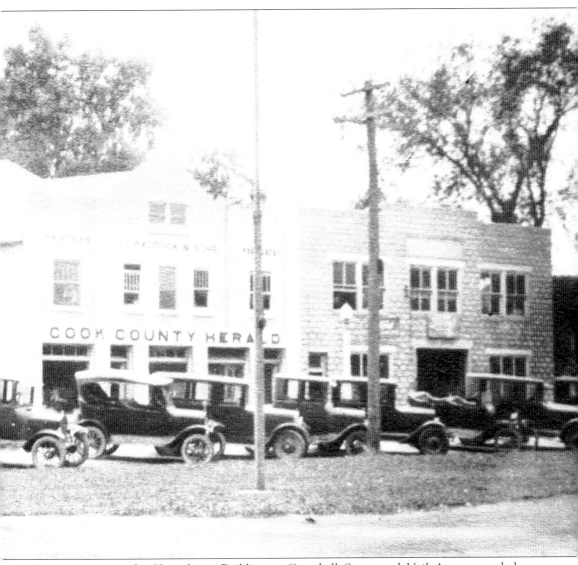

COOK COUNTY HERALD

Dunton Avenue, the Hagenbring Building at Campbell Street and Vail Avenue, and the Greenberg Building on Northwest Highway. Some light industries made their way into the village as well. East of State Road along Northwest Highway, Rowles School Manufacturing and Arlington Concrete Products set up shop in Arlington Heights. In this picture, it appears that parking is already at a premium. (Photo courtesy of Arlington Heights Historical Society.)

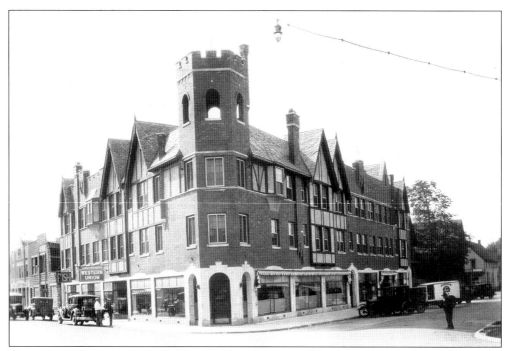

VAIL-DAVIS BUILDING, 1928. This building was part of the construction frenzy during the mid-to-late 1920s. The Tudor style was in vogue then—a marked contrast to the rural frame-style structures of the previous decades. Developers felt that the village needed a more elegant image if it was to attract new residents, businesses, and shoppers. This type of design was repeated in the new buildings erected along Northwest Highway. (Photo courtesy of Arlington Heights Historical Society.)

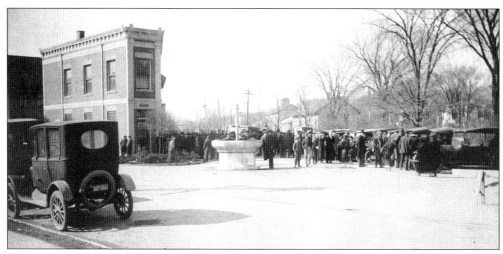

PEOPLE'S STATE BANK, 1920S. The Depression was not far off, but during the 1920s, this bank helped to finance the building projects in the downtown area. When it closed in 1932, the town was left with no banking facilities. (The Arlington Heights State Bank had closed a year earlier.) This picture was taken during an auction. The horse-watering trough in the foreground was scheduled to be dismantled. (Photo courtesy of Arlington Heights Historical Society.)

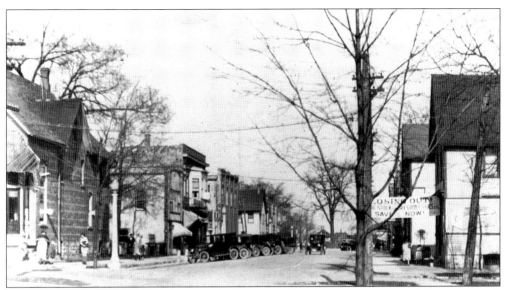

CAMPBELL STREET, 1925. This view is looking east from Vail Avenue toward Dunton. At 1 and 3 East Campbell Street (way down the street on the right) Waldemar Krause began a face-lifting project by remodeling the old Madison House Tavern. He lowered the floors and provided space for two new stores. Other buildings on the block included taverns, a cigar store on the south, and a drugstore and phone exchange on the north. (Photo courtesy of Arlington Heights Historical Society.)

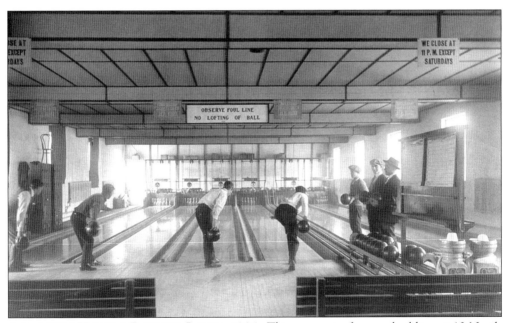

ARLINGTON HEIGHTS BOWLING LANES, 1924. This was part of a new building at 10 North Vail Avenue. At this time, the balls had only two finger holes for the men and three for ladies and children. Nothing was automatic then. Boys sat behind the pins and reset them after each frame. Sometimes a sympathetic pin boy would place a pin in the gutter to help the inept bowler score a point. (Photo courtesy of Arlington Heights Historical Society.)

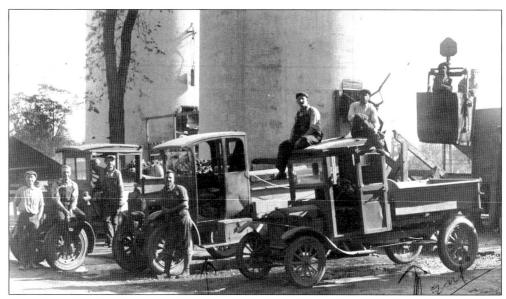

SCHNEBERGER ELEVATOR AND COAL. Gottlieb Schneberger purchased this operation at 215 West Northwest Highway from Sherman Pate shortly before World War I. He added three more silos to house sand and gravel. Between 1920 and 1928, another six were built. The silos were a fixture along the railroad tracks until they outgrew their usefulness and were torn down in the mid-1960s. (Photo courtesy of Arlington Heights Historical Society.)

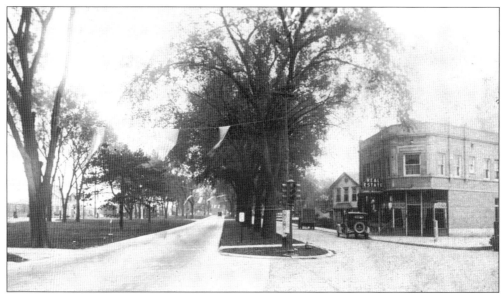

NORTHWEST HIGHWAY, 1920S. This road was the vision of William Busse and Albert Volz, who in 1918, envisioned a paved road running along the railroad tracks through the northwest suburbs, giving travelers a more direct route from the outskirts of Chicago. The highway was completed in the mid-1920s, and widened in 1928, necessitating the destruction of the trees shown here on Mors Parkway. (Photo courtesy of Arlington Heights Historical Society.)

Four

SURVIVING THE
GREAT DEPRESSION

When the Depression hit, many thought it nothing more than a temporary setback. The *Arlington Heights Herald* didn't even mention the October 1929 crash, and few felt the full impact of this economic downturn until 1930. However, by 1930, the villagers and retailers could not ignore the inevitable. Building projects in the downtown area had been completed, but any future plans were put on hold. Some businesses failed; others managed to survive through the barter system. Unemployed men pleaded with the village board to give them any kind of work, but there was simply none to be had. The board responded by establishing a Relief Committee, composed of a church member and a community nurse. During the first month of operation, the committee had furnished 120 requests for groceries, coal, and milk. The town's two banks that had closed reopened under new management by the late 1930s. It appeared that Arlington Heights had weathered the worst of it, when government funding came through to help construct a new swimming pool and park. Things were looking up.

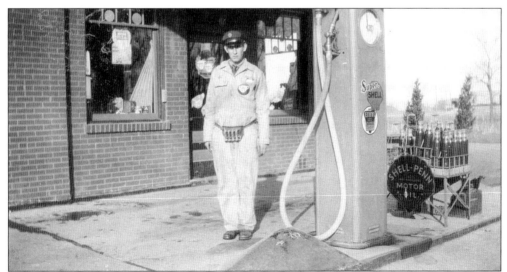

VIRGIL HORATH, 1935. Virgil Horath opened this gas station in 1935, at the corner of Northwest Highway and Belmont Avenue, just north and east of the center of town at the height of the Depression. Horath was one of 16 charter members of the Arlington Heights Historical Society. His widow, Helen, was the last surviving charter member until her death in 2000. (Photo courtesy of Helen Horath Estate.)

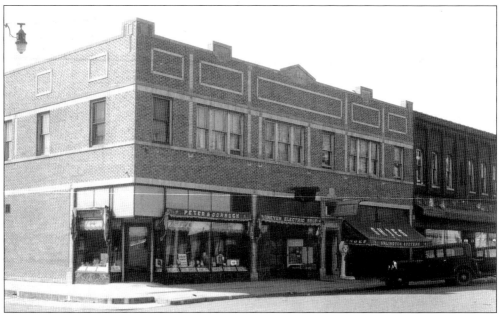

CAMPBELL STREET, EARLY 1930s. The effects of Black Friday in October 1929, were beginning to be felt. The tenants of these buildings probably took crops and services in payment for their goods. One barber claimed that it was not unusual for him to get payment for a haircut with a bag of corn. Between 1929 and 1935, 20 businesses went vacant. (Photo courtesy of Arlington Heights Historical Society.)

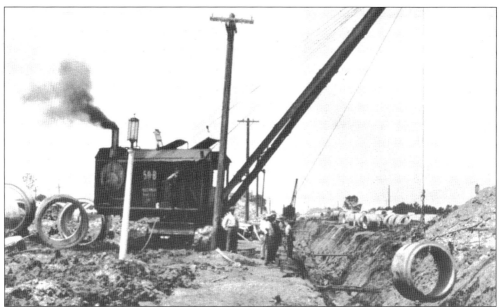

SEWER LINE INSTALLATION, 1930. After a heady construction and road-building boom during the 1920s, the village now had an urgent need for a more sophisticated sewer system. The battles over the plans and cost went on for some time, but finally in late 1929, a 2-yard excavator arrived to begin construction on the project. (Photo courtesy of Arlington Heights Historical Society.)

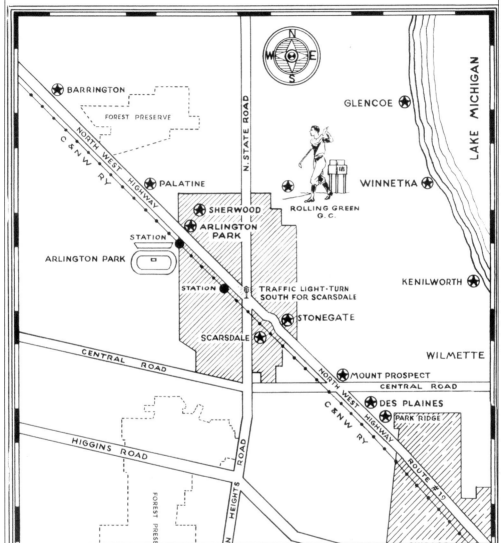

MAP IN ADVERTISING BROCHURE. In 1930, Arlington Heights was still trying to lure prospective homebuyers to the village. This map shows the village's proximity to the city and the newly constructed Northwest Highway, giving travelers a "straight shot" into Chicago or out to Barrington and beyond. The Scarsdale and Stonegate subdivisions east of State Road (eventually Arlington Heights Road), were the biggest sellers with their upscale housing and attractively curved streets and parkways. Yet, the homes were virtually within walking distance of the train station and shopping. The Scarsdale enterprise nearly failed in the middle of the Depression when sales dried up. Fortunately, local realtor C.M. Behrens convinced Tackett and Drake (who had bought out the original backers), to sell lots below their original value. Tackett-built homes were known for their high quality and durability. This helped to boost sales, and Scarsdale was saved. (Photo courtesy of Arlington Heights Historical Society.)

55

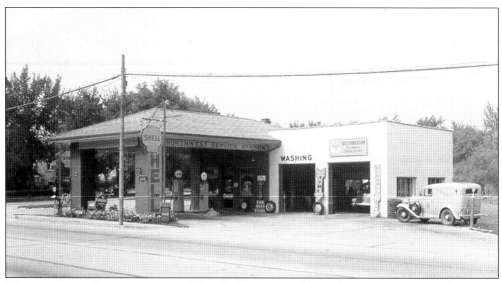

HORATH SHELL STATION, 1930S. This Shell station still stands in 2001. It is now known as Grandt's Shell. After Northwest Highway was widened in the late 1920s, gas stations along the route did a thriving business. That may explain why this station has survived into the twenty-first century. (Photo courtesy of Helen Horath Estate.)

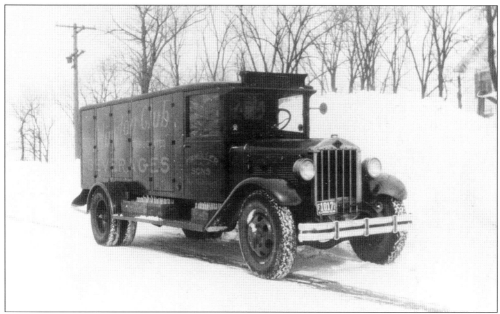

ARLINGTON CLUB BEVERAGE TRUCK, c. 1930. This company was originally known as F.W. Muller Carbonated Beverages from the late 1870s until 1923, when Frederick Muller retired. His sons, William and Henry, took over, and they changed the name to Arlington Club Beverages. The manufacturing plant was located on Fremont Street just west of Vail Avenue, the site of the present Arlington Heights Historical Museum. Arlington Club moved to a warehouse on Central Road in 1964. (Photo courtesy of Arlington Heights Historical Society.)

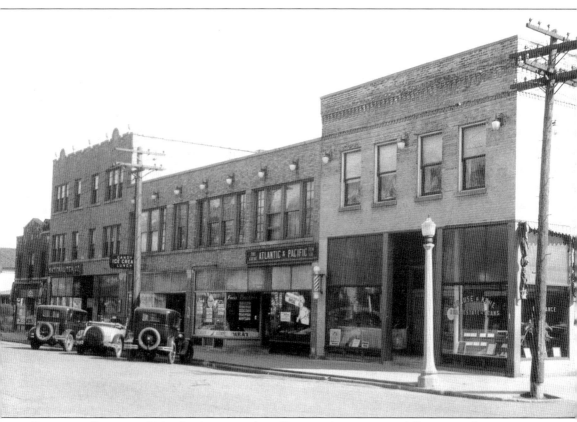

CAMPBELL STREET, 1930S. Looking east from Dunton Avenue toward Evergreen Avenue is Krause and Kehe Real Estate, the Atlantic and Pacific Tea Company, and an ice cream store. At the far end of the block is the Lauterberg Tavern, now the site of the Citibank building. While this street looks relatively stable, a number of businesses in the village failed in the 1930s, because property values assessed in 1928 had skyrocketed from the previous years, resulting in a sharp increase in taxes. When the Depression hit, many retailers were unable to meet the tax payments and were forced to sell out. This in turn affected the village government and the services it was expected to supply. With very little tax money coming in, village officials couldn't make the payroll. They solved this by issuing tax anticipation warrants, which meant that salaries would be paid later when funds were available. However, that didn't buy goods and groceries, since many retailers refused to accept these warrants. (Photo courtesy Arlington Heights Historical Society.)

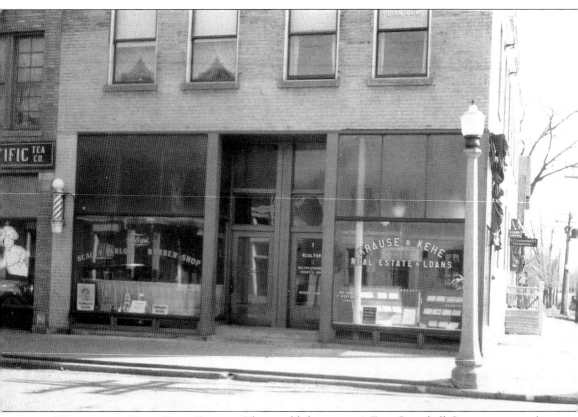

KRAUSE AND KEHE REAL ESTATE. This establishment at 1 East Campbell Street came to the rescue when the Arlington Heights State Bank and the People's Bank failed in the early 1930s. Walter Krause and Ed Kehe opened a currency exchange so people could get cash and take out small loans. The barbershop next door, like so many other businesses, most likely took goods in place of money for his services. People did whatever they could to survive. Rabbit raising cooperatives sprang up on the southern end of town. To keep their spirits up, people held holiday festivals, dances, and visited with neighbors. The Arlington Theatre, on the north side of the tracks, held a food drive for the needy. Patrons were asked to bring canned food in lieu of admission. Walter Krause also succeeded in getting a WPA (Works Progress Administration) grant from the government to enable the village to construct a municipal swimming pool. A recreation pool and park were completed in the late 1930s. (Photo courtesy of Helen Horath Estate.)

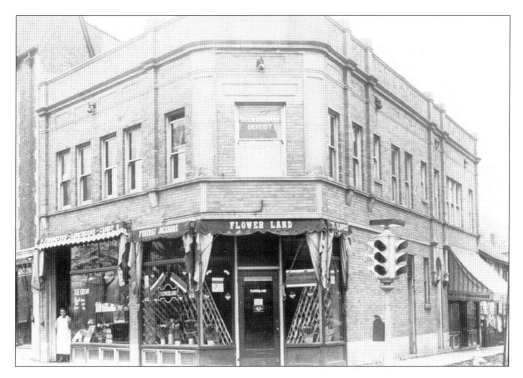

KUHLMAN'S DELICATESSEN AND FLOWER LAND, 1935. These buildings were located on the north side of the tracks at 26 and 28 East Northwest Highway, respectively. The large German population loved to eat and depended on delicatessens such as this for entertaining and for just enjoying good food. Flower Land stood at the corner of Evergreen Avenue. As of this writing, a gourmet coffee shop is located there for the convenience of commuters. (Photos courtesy of Arlington Heights Historical Society.)

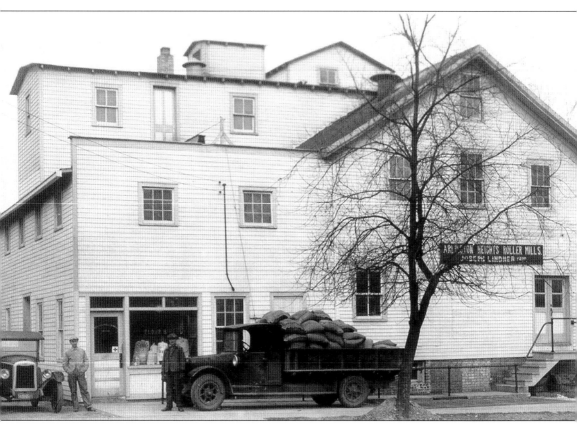

ROLLER MILL, c. 1930. This roller mill stood on the corner of Wing and State Roads, just north of Northwest Highway. It was built in 1862, and lasted 100 years at that location. Farmers in the area would bring their produce to the mill for grinding into flour or feed. The mill also sold its products to nationally known feed companies. Although "white collar" businesses and shops were on the increase north of the tracks, it appears that most of the rural industries were concentrated in that area of town. A creamery stood on that same corner across the street. Because of the many churches in that area, it was known as "Piety Hill." The roller mill was demolished in 1962, to make room for the Arlington Theatre parking lot, and with it went one of the last symbols of a town sustained by hard-working men and women of the soil. (Photo courtesy of Arlington Heights Historical Society.)

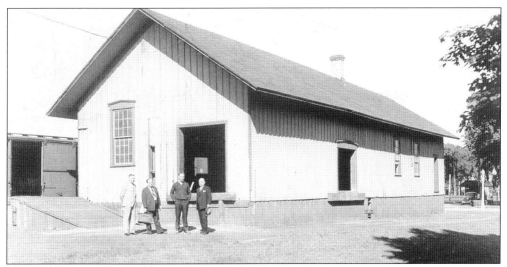

ORIGINAL RAILROAD STATION, 1930. The original 1854 depot remained in use for close to 40 years after its demotion to a freight shed in 1892. Here Walter Krause, Victor Grimmer, George Schneberger, and Henry Muller, all prominent businessmen in town, pose in front of the venerable building. The depot was demolished shortly after this picture was taken to make way for a new track. (Photo courtesy of Arlington Heights Historical Society.)

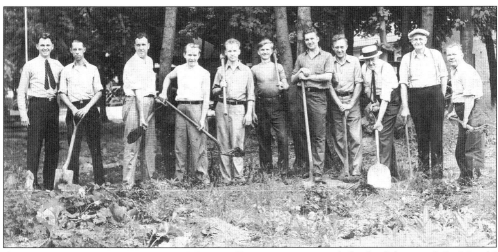

GROUNDBREAKING FOR THE NEW HERALD BUILDING, 1939. A fire had damaged the Herald building on Davis Street in 1938, forcing the paper to move a few blocks west to 217 West Campbell. Those strapping young men hefting shovels are, from left to right: Stuart Paddock Jr., Edward Duenn, Forrest Davis, Art Schoepke, Butch Schoepke, Ralph Nebel, Dick Wessel, Stuart Paddock Sr., Charles Paddock, and Paul Arneman. (Photo courtesy of Arlington Heights Historical Society.)

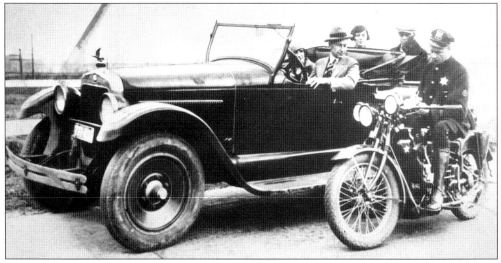

WHAT'S THE PROBLEM, OFFICER? By the end of the 1920s, Northwest Highway was heavily used, and during the racing season it became little more than a drag strip. Prohibition was still in effect. People had little regard for laws forbidding gambling and alcohol. Policemen patrolled the streets in motorcycles, braving the winter winds. In 1930, the board broke down and purchased a used 1929 Plymouth sedan. (Photo courtesy of the Arlington Heights Police Department.)

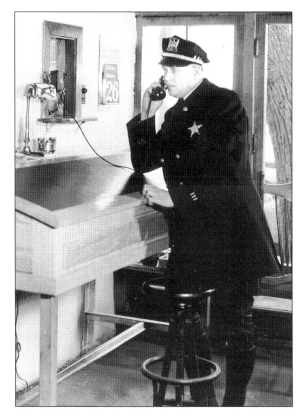

CHIEF SKOOG. Part-time police patrol proved inadequate by the mid-1920s. Although the village had a full-time officer for a brief period until the board discontinued the position, it soon became apparent that the office should be reinstated. Carl Skoog was hired and held the position until 1957. He spent his days patrolling the streets in a motorcycle from 9:00 a.m. to 10:30 p.m., summer and winter. (Photo courtesy of the Arlington Heights Police Department.)

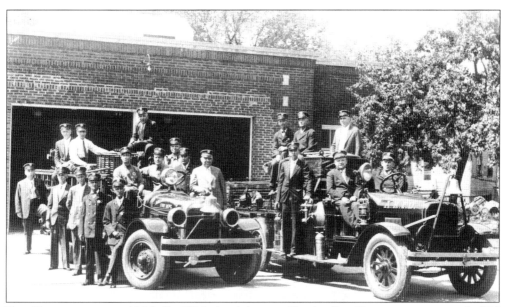

FIRE DEPARTMENT, c. 1935. By 1924, the Arlington Heights Fire Department consisted of 26 men. Here they are shown with their pumper and hook-and-ladder equipment. By this time, the fire department operated out of the new village hall at Vail Avenue, Davis, and Wing Streets. (Photo courtesy of the Arlington Heights Fire Department.)

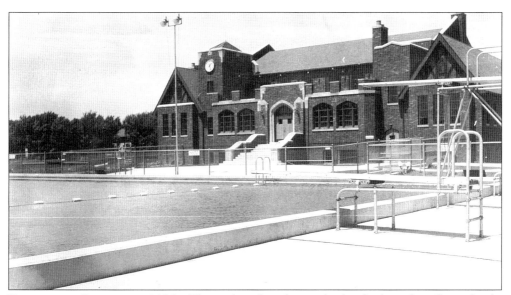

RECREATION PARK, LATE 1930S. This park and pool were the first built in the village, thanks to a WPA grant. George Schneberger, Walter Krause, and then mayor Julius Flentie submitted their plan just in time for the board to consider granting funds toward the project. "Rec Park," within walking distance of downtown, looks the same today and is the site of the yearly "Frontier Days" festival. (Photo courtesy of Arlington Heights Historical Society.)

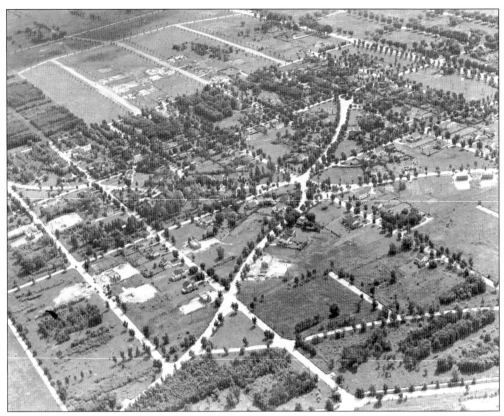

AERIAL VIEW OF SCARSDALE AREA. With the Depression at its peak, there were few, if any, buyers for these lots. One homebuilder offered to sell his lots for $50 apiece to anyone who could pay the taxes. Unfortunately, no one could afford the $50, much less the taxes, which were quite high at the time. Some building sites are visible here, and it's obvious from the creative plotting that the developers had ambitious plans for this upscale community. While there was some construction during the 1930s, homebuilding did not get into full swing again until after World War II . Today, any Scarsdale address carries a fair amount of prestige. This view looks west and north toward Arlington Heights Road. (Photo courtesy of Arlington Heights Historical Society.)

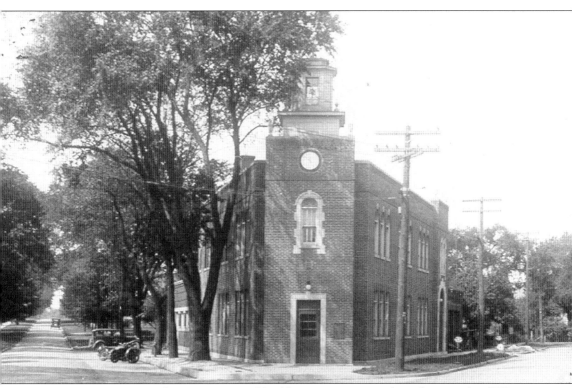

VILLAGE HALL, 1930. The new municipal building was constructed on the triangle of Wing Street, Vail Avenue, and Davis Street as a one-story structure in 1913. For decades, village business had been conducted in various locations. The Taege Hall at 2 North Dunton Avenue served as the village hall from 1887 to 1891. The Meyer Hall, on the second floor of the bank at 14 East Campbell Street, was used until 1893, when the village officials moved their operations to the newly remodeled Luettge house. That house was moved to 925 North Dunton Avenue to make way for this structure, which also housed the fire department. A second story was added in 1930. Village business was conducted in this building until 1962, when a new municipal building was erected at Sigwalt Street and Arlington Heights Road. That same year, this structure was torn down to make way for the Jewel Food store and parking lot. (Photo courtesy of Arlington Heights Historical Society.)

JULIUS FLENTIE. Flentie served as mayor of Arlington Heights from 1927 to 1941, but his history with the village spans several decades. At the age of 16, he became the village's first telephone operator. In 1917, he and two other firemen raised $1,900 for motorized fire equipment. During the worst years of the Depression, he managed to secure funds from state and federal governments to finance several public works projects, thus providing employment for many Arlington Heights citizens. (Photo courtesy of Arlington Heights Historical Society.)

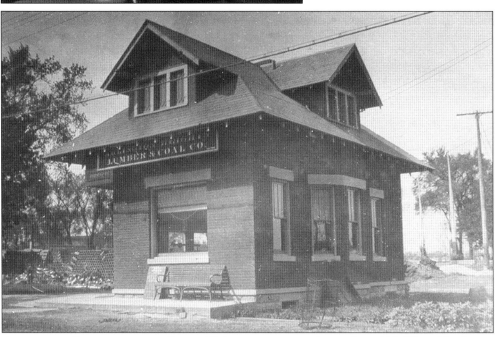

ARLINGTON ELEVATOR AND COAL. This company was located at 215 West Northwest Highway and had operated under various names since 1873. The company closed down in the 1960s. By then, the use of coal had gradually declined as more homes were heated with gas or oil. (Photo courtesy of Arlington Heights Historical Society.)

Five

THE WAR AND GROWING UP

No sooner had people begun to recover from the Depression than World War II forced the villagers and merchants to make do once again. People stood in line outside of butcher shops waiting for any meat that might be available. Car dealers, with nothing to sell, turned to automobile repair to keep their establishments going. Once the war ended and soldiers returned home, the demand for housing increased. Everyone wanted the good life—a nice house in the suburbs, a car, and 2.5 children. Arlington Heights benefited from all this. Land was plentiful, and by the 1950s, subdivisions had spread out north and south from the center of town, creating a meandering village boundary. Mount Prospect and the new community of Rolling Meadows filled in the east and west gaps bordering Arlington Heights. Families needed two cars and convenient shopping. Strip malls, covering former cornfields with cement and brick, began to appear, and the larger indoor malls were not far behind. Few could foresee the tremendous impact this would have on the central business district.

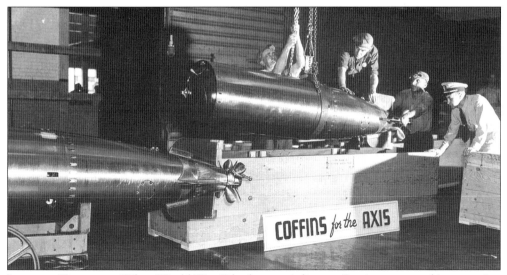

LOADING TORPEDOS. When World War II broke out, Arlington Seating revamped its operation and focused on war manufacturing after securing contracts with the Navy to build torpedo and bomb crates. Although the country was seeing the beginning of the end of the Depression, it was asked to make sacrifices for the war effort. Rationing, blackouts, and sending its sons off to fight became a way of life. (Photo courtesy of Arlington Heights Historical Society.)

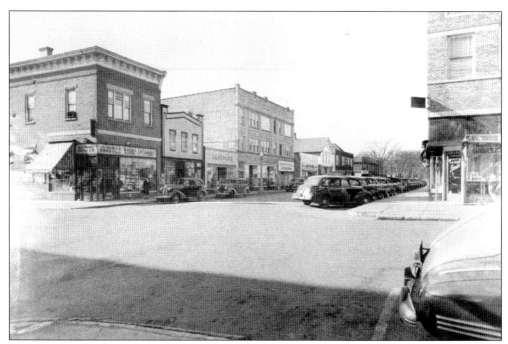

CAMPBELL AND DUNTON AVENUES. Sieburg Drugs was a popular gathering place for soldiers when they came home for leave during World War II. People flocked to Seiburg's when the word went out that the store had received a fresh carton or two of cigarettes or if a few pair of nylon stockings had arrived. (Photo courtesy of Arlington Heights Historical Society.)

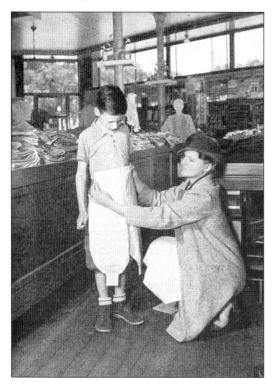

GIESKE'S STORE. Gieske's was still the place to shop in town for school clothes. This store on Davis Street had been a fixture in the village since the 1900s, and lasted until the mid-1960s. A shopper could enjoy individual attention and knew the salespeople on a first name basis—a far cry from impersonal fluorescent-lit "anchor stores" of today. (Photo courtesy of Arlington Heights Historical Society.)

LANDMEIER HARDWARE, EARLY 1940S. The Landmeier Building at 7 West Campbell was erected during the 1920s prosperity. In the early 1940s, the hardware store at 5 West Campbell and the Ben Franklin store at 7 to 9 West Campbell were the building's main occupants. Further down were Arlington Provisions (a meat packing company) and a Jewel Food Store. Previously, the Jewel location had been home to an A&P and National Foods. (Photo courtesy of Arlington Heights Historical Society.)

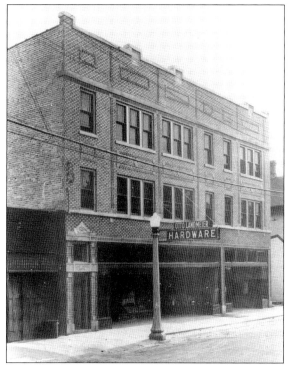

PARKVIEW TAVERN. During World War II, Mar Johnson, owner of the Parkview Tavern, kept a toy bank on the counter and asked customers to drop in any spare change for their men overseas. Each week he held a drawing to determine which of Arlington Heights' fighting men would win the money. The cash was converted to travelers' checks and mailed to the winner. Many servicemen were pleasantly surprised to get a bonus in a letter from home. (Photo courtesy of Arlington Heights Historical Society.)

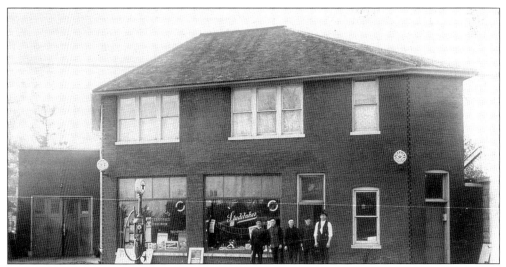

GAARE STUDEBAKER. Henry Gaare operated this garage from 1914 to 1944, at 115 East Davis Street. Since auto manufacturing had been put on hold during the war years, Gaare had nothing new to sell. War time rationing didn't help. He finally decided to auction his business and retired to California. (Photo courtesy of Arlington Heights Historical Society.)

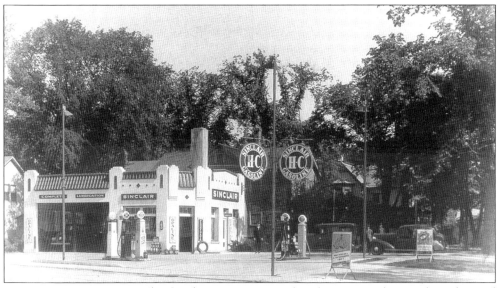

DIEBER SINCLAIR, 1940s. This Sinclair station on South Arlington Heights Road was featured in a movie produced by the Lion's Club in 1941. The film's plot line showed a couple about to be married shopping for cars, appliances, and an engagement ring in downtown Arlington Heights. Shortly after a lovers' quarrel, the man decides to leave town, but not before filling up at this Sinclair station. The station was replaced by a new building in 1963. (Photo courtesy of Arlington Heights Historical Society.)

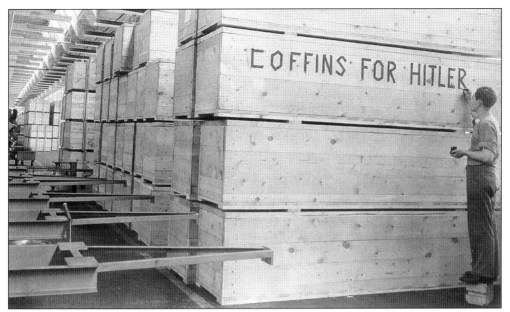

GUN CASES. The need for Arlington Seating Company's products had dwindled by early 1945, and the company was left with an overabundance of white pine. A housing shortage caused by returning G.I.'s looking for places to live resulted in a demand for building materials. Arlington Seating sold its leftover wood to Heller Lumber down the street for use in home construction. Many older homes today are made of "Hitler Coffins." (Photo courtesy of Arlington Heights Historical Society.)

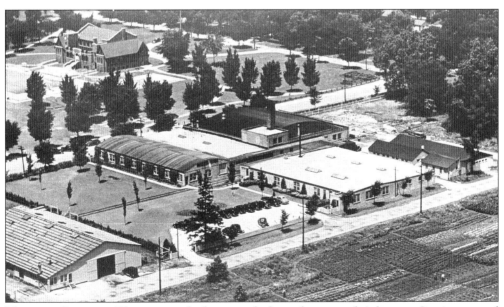

VICTORY GARDEN. This view is looking north from the area of Arlington Seating toward Recreation Park on Miner Street, just north of town. A victory garden is in the foreground. Heller Lumber is located across the street, and Recreation Park Fieldhouse is at the top left. More light industry would replace the tomatoes and beans after the war. (Photo courtesy of Arlington Heights Historical Society.)

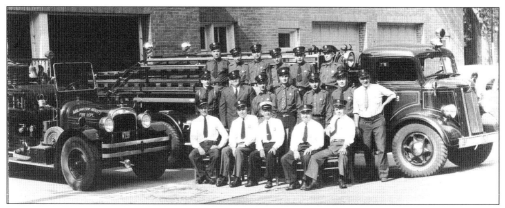

FIRE DEPARTMENT, 1944. During World War II, the department contributed sirens from fire trucks, police cars, and the fire chief's car for the war effort. Also, the Auxiliary Fire Department was formed, made up of men just above draft age. (Photo courtesy of Arlington Heights Historical Society.)

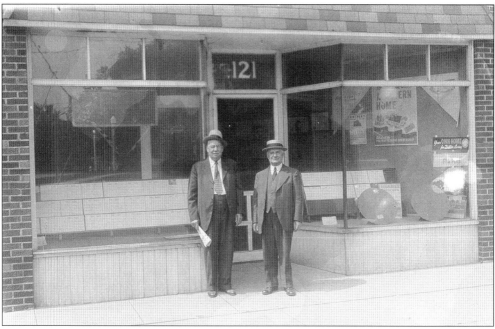

PFINGSTEN AND BOUFFARD REAL ESTATE. This business operated at 121 East Davis Street between 1939 and 1945. If they had stayed in business just a little longer, they might have been caught up in the post-war prosperity and demand for housing. By this time, Meyer's Pond, just east of this location on the other side of State Road, had been filled in when the road was widened. (Photo courtesy of Arlington Heights Historical Society.)

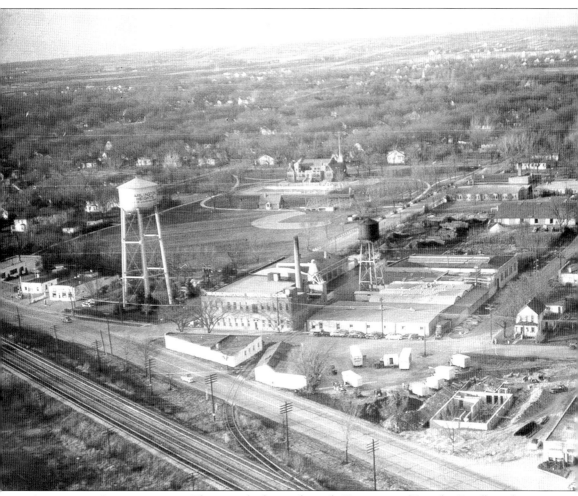

ARLINGTON SEATING, 1940. This view looks north, with Kensington (Foundry Road) in the foreground and Northwest Highway running along the tracks. The water tower in the background was eventually torn down, and a larger and more sophisticated one was built at the south end of town. A spur from the Chicago & Northwestern tracks ran across Northwest Highway and to the back end of Arlington Seating. In the center are Recreation Park Field House and the athletic field. In 1961, Arlington Seating was sold to Continental Materials Company. Two years later, the operation moved to Antioch, Illinois. That stretch of land now houses, among other things, a Mexican restaurant, a convenience store, and a cleaners. The wedge-shaped building where Kensington and Northwest Highway meet has recently been torn down. (Photo courtesy of Arlington Heights Historical Society.)

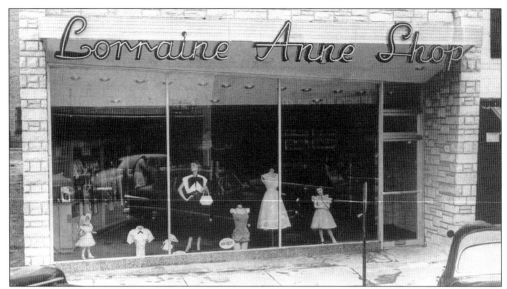

LORRAINE ANNE SHOP, 1950S. The business operated on the north side of Campbell Street. During the 1940s and most of the 1950s, women still shopped for clothes in the Central business district. Often other women owned stores of this type, and enough shops existed in town to promote healthy competition. Malls began to appear during the late 1950s. One of the first in the area was Old Orchard in nearby Skokie. (Photo courtesy of Arlington Heights Planning Commission.)

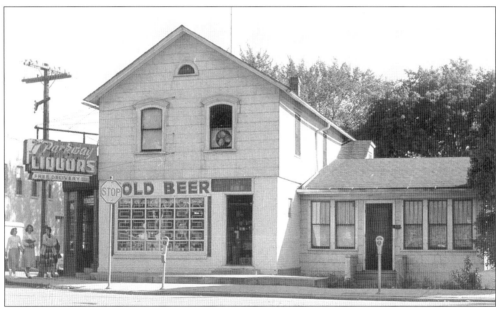

PARKWAY LIQUORS, 1958. Originally known as the "Wheeling House," built as a tavern and boarding house at Evergreen Avenue and Campbell Street in 1855, this structure survived over the years under several ownerships. According to one newspaper account, at the time this photo was taken, Parkway Liquors would move next door to a new building and this one was scheduled for razing to make way for the colonial style Arlington Federal Savings. (Photo courtesy of Arlington Heights Planning Commission.)

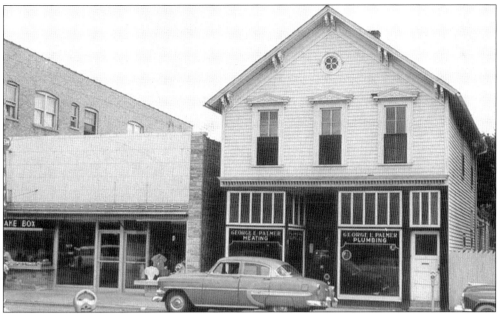

PLUMBING BUSINESS, 1950S. This frame building stood at 18 West Campbell Street. A number of frame structures still existed downtown. Eventually this building was torn down, and the Cake Box moved across the street. In the late 1970s, the Cake Box, like so many other businesses in the area, closed up shop and moved elsewhere. The bakery found a new home in a strip mall a few blocks west of town. (Photo courtesy of Arlington Heights Historical Society.)

UNION HOTEL, 1958. One of the first hotels to be built in the mid-1800s, the Union Hotel was still around in the 1950s, after several refurbishings. It was eventually demolished to allow for expansion of the Arlington Heights National Bank, which is now Bank One. The Union stood just west of the bank at Dunton Avenue and Davis Streets. (Photo courtesy of Arlington Heights Historical Society.)

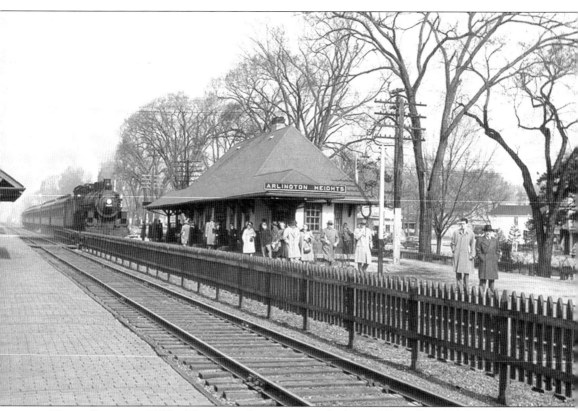

TRAIN STATION, 1950S. The original train station, built in 1892, still served the village well into the 1960s. The locomotive you see coming down the track was close to heaving its last puff of smoke. While steam engines had gone above and beyond the call of duty during World War II, they were destined to be scrapped after the war, when improved roads made car travel more attractive, and industry turned to trucking for hauling goods. Commuters took the train into the city and back, but that hardly made up for the shortfall due to reduced freight transportation. The Chicago & Northwestern made ready to scrap the wheezing steam train for the high-powered diesel. On Friday, May 8, 1956, the last steam train pulled out of Chicago's Northwestern station taking its passengers home. (Photo courtesy of Arlington Heights Historical Society.)

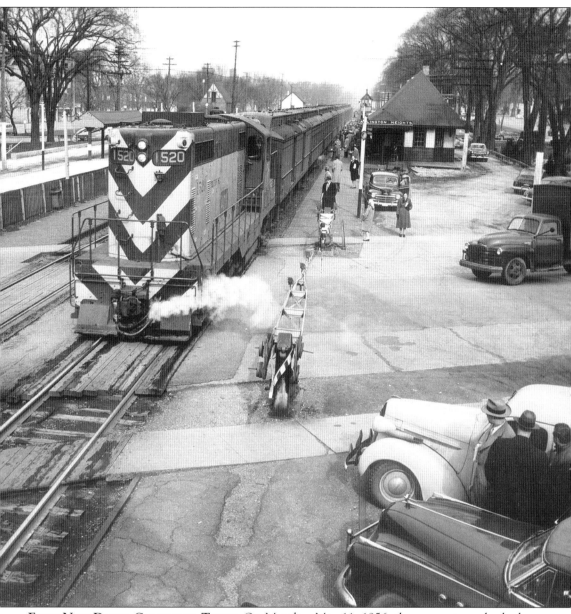

FIRST NEW DIESEL COMMUTER TRAIN. On Monday, May 11, 1956, the commuters who had come home on the coughing, sooty steam train the previous Friday returned to work in comfort in a civilized diesel locomotive. Over the weekend, the Chicago & Northwestern had finagled every diesel locomotive they could find to be ready for the commuter onslaught Monday morning. For travelers into the city, steam was a thing of the past. Arlington Heights' train depot was also given a facelift. A new paint job and stripping of the Victorian scrollwork helped match it to the streamlined style of the '50s. There were other signs that the railroads were on the decline. Unnecessary sidings had been pulled up or paved. Switches and gate towers were taken down. In 1976, the old 1892 depot became history when it was demolished to make way for a colonial structure. (After all, it was the year of the bicentennial.) (Photo courtesy of Arlington Heights Historical Society.)

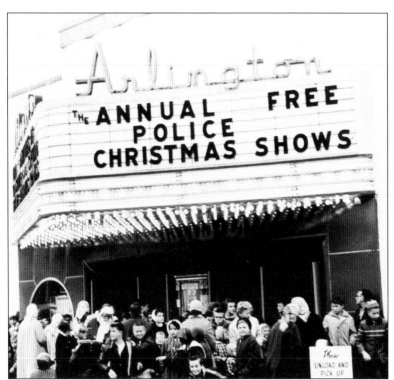

ARLINGTON THEATRE. The Arlington Theatre was built in the mid-1920s, before the advent of the talkies. During the holidays, the police department threw a Christmas party for the children in the town at the Arlington Theatre, with free popcorn and candy while their parents went shopping. (Photo courtesy of Arlington Heights Historical Society.)

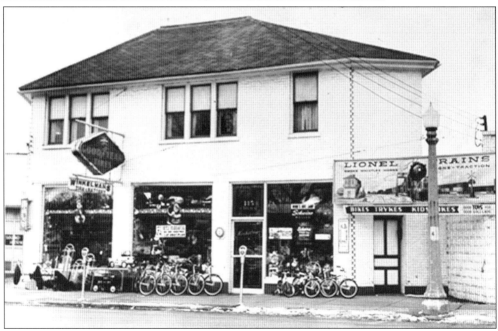

WINKELMAN'S BIKE SHOP, c. 1950s. This store was located at 115 East Davis Street. After the war, as families grew and relocated to the suburbs, every kid had to have a bike. Looks like Winkelman catered to other hobbies as well. When snow filled the streets, a boy and his father could count on Winkelman's to supply them with electric trains to play with during the long winter evenings. (Photo courtesy of Arlington Heights Historical Society.)

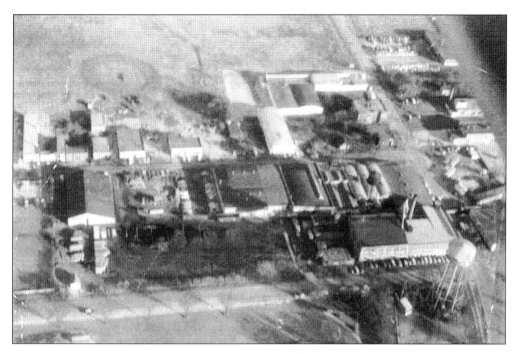

FUTURE HOME OF THE STRIP MALL, 1950S. This aerial view looks east past Arlington Seating; Kensington Street and Northwest Highway meet at the far right of the photo. The street near the bottom is Douglas Avenue. Plans were afoot to build a multipurpose shopping mall with grocery, drug, clothing, and specialty stores in the area at the top and off to the left. For the moment, the land was perfect for the demolition derbies that took place on weekends. The crippled automobile below was purchased for about $25. After it fought in the derby, whatever was left was sold to the junkman. (Top photo courtesy of Arlington Heights Historical Society, bottom photo courtesy of Dale Meyer.)

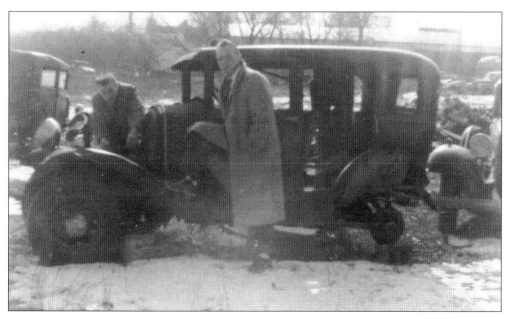

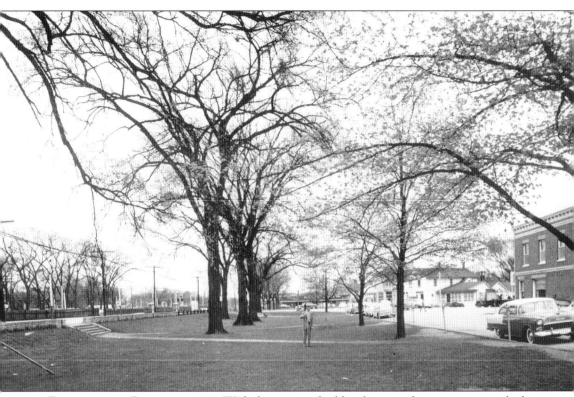

REMOVING THE PARKWAY, 1958. With the post-war building boom under way, more people than ever worked in the city and lived in the suburbs. The need for downtown parking had been a problem since the late 1940s, but by the 1950s, it became virtually impossible to find a spot anywhere within walking distance of the station. At the same time, the Chicago & Northwestern, in an economy move, decided to sell the Railroad Park land to the highest bidder. The Arlington Heights Board purchased the land through a bond issue and made the painful decision to cut down these trees and pave over the grass to allow for more automobiles. This view looks east, showing Davis Street on the right. (Photo courtesy of Arlington Heights Planning Commission.)

Six

A PERIOD OF PLANNING

During the 1960s, downtown Arlington Heights started to experience a gradual atrophy in its basic structure. People discovered malls and giant supermarkets with wide aisles and unlimited choices. Why would they choose to shop in an area where they had to maintain their parallel parking skills just to maneuver the cumbersome family automobile into a cramped parking space? Only then to discover that the few stores left in the Campbell-Dunton-Vail area had such limited stock? This situation was not lost on the city fathers who saw the exodus as a problem that could only get worse. Any kind of change required the public's support. The village could tear down and rebuild, but if it didn't work, then they were stuck. Plans were proposed, then discarded. Village officials were elected, lived out their terms, or were reelected, but treated the downtown situation like a hot potato. No one wanted to make a decision only to have it backfire. As then mayor John Woods said in 1963, smaller structures had "lived beyond their economically useful life."

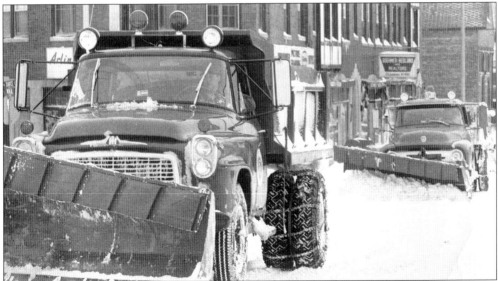

PLOWING AFTER THE BIG SNOW. Few people in the Chicago area who were alive during this time can forget the "Big Snow of '67." More than 2 feet of snow fell on January 26, 1967. These plows are struggling through one of the downtown streets, dumping the white stuff wherever they can. (Photo courtesy of Arlington Heights Planning Commission.)

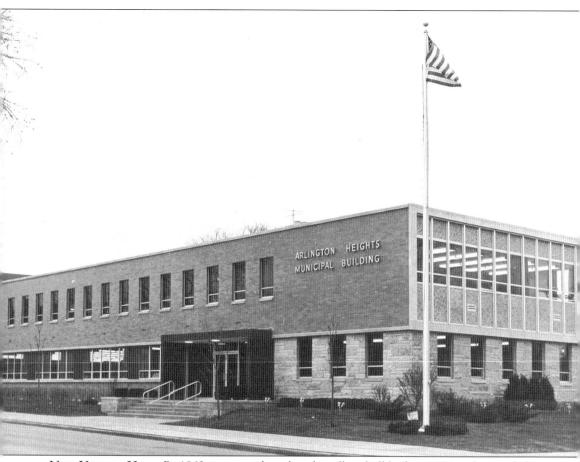

NEW VILLAGE HALL. By 1962, it was evident that the village hall built in 1913 and expanded in 1930 was no longer adequate enough to serve the town's growing population. The groundbreaking for this building, situated at Arlington Heights Road and Sigwalt Street, began in early 1962. Meanwhile, the government moved its operations to a temporary location north of the tracks and a short distance west of downtown. This new building was ready for its owners to move in and do business by December 1962. (Photo courtesy of Arlington Heights Historical Society.)

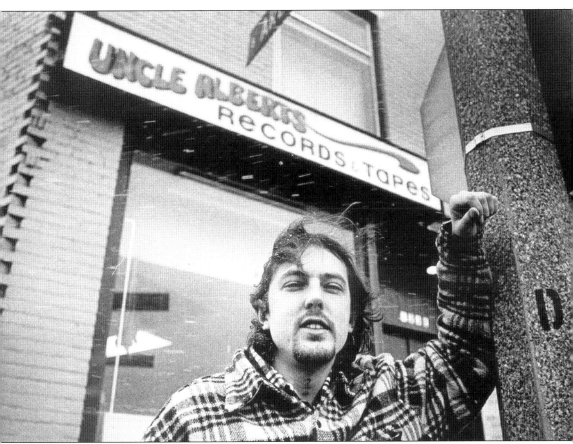

UNCLE ALBERTS. John Olsen is shown in front of his store at the corner of Davis Street and Arlington Heights Road, just south of the railroad tracks. A plan discussed in 1976 concerned installing an underpass at this intersection to ease traffic at the railroad crossing, but consequently forcing the widening of Arlington Heights Road and demolishing Olsen's operation. The underpass never materialized. The building was torn down eventually and was replaced by a one-story building that housed a ski and patio shop. That became a stopgap measure at best. As the years went on, sporadic building revamping and replacing did not bring in the anticipated additional retail revenue. The city planners needed a more aggressive approach to revitalization. But what? (Photo courtesy of Arlington Heights Historical Society.)

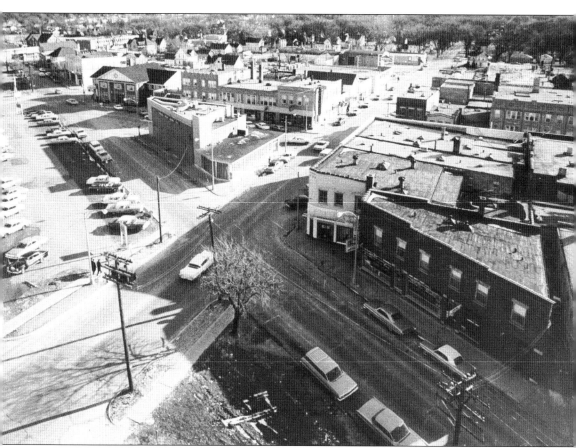

Aerial View of the Central Business District, 1960s. Looking south from the railroad tracks, Davis Street runs from the top left toward the bottom right. Dunton Avenue intersects it. The wedge-shaped building in the upper part of the photo and to the left is the Arlington Heights National Bank, known as the Peoples Bank before the Depression. The Union Hotel, which had stood in that same triangle, was torn down. The Arlington Heights Federal Bank just to the upper left had also replaced a tavern that had been a small hotel in the 1900s. The era of small town hotels catering to traveling salesmen was fading. Air travel became the accepted mode of getting from point A to point B. Most travelers now stayed at "motels" on the outskirts of town, near the airport. (Photo courtesy of Arlington Heights Historical Society.)

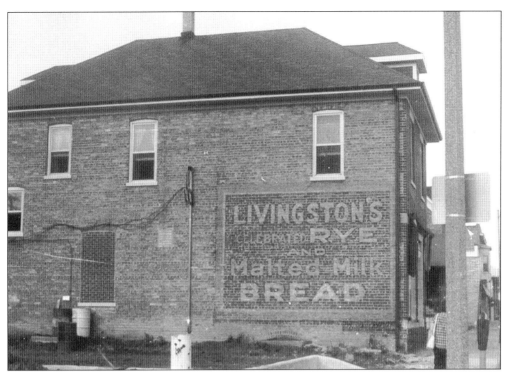

VAIL AVENUE NORTH OF CAMPBELL STREET, 1978. The advertisement painted on the wall is also a symbol of a bygone era. Where is Livingstone's Rye Bread now? Down the street is the "twin-peaked" Engelking Building. The Village Green complex replaced the buildings on this block. (Photo courtesy of Arlington Heights Historical Society.)

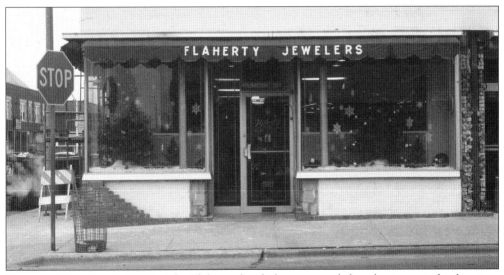

FLAHERTY JEWELERS, 1960s. The Flaherty family has operated their business at this location since 1947. Both Flaherty and Mitchell Jewelers have survived the rise and fall and rise again of Arlington Heights' central business district. Although the malls and discount stores drew most shoppers, some Arlington Heights residents continued to patronize merchants that offered more personal service. (Photo courtesy of Flaherty Jewelers.)

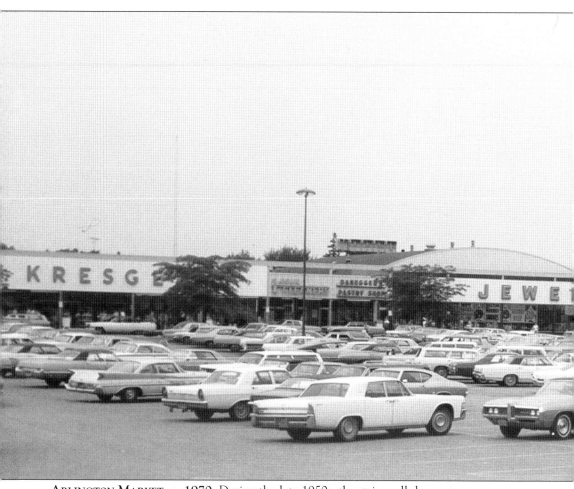

ARLINGTON MARKET, c. 1970. During the late 1950s, the strip malls began to emerge as more and more "bedroom communities" sprang up. The Arlington Market, north of the railroad tracks and just east of downtown (the site of the demolition derbies a few years earlier), was built in 1958, to accommodate residents who needed one-stop shopping in a location that

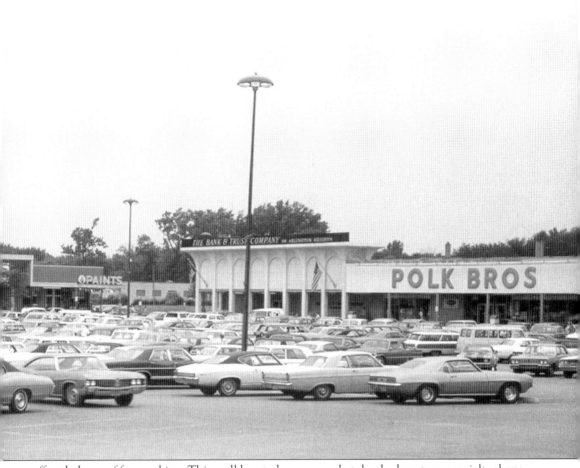

offered plenty of free parking. This mall boasted a supermarket, bank, drugstore, specialty shops, and a variety store. The central business district was hard-pressed to offer anything as attractive. Kresge's even had a lunch counter. At one time, two grocery stores operated at either end of the strip. (Photo courtesy of Arlington Heights Historical Society.)

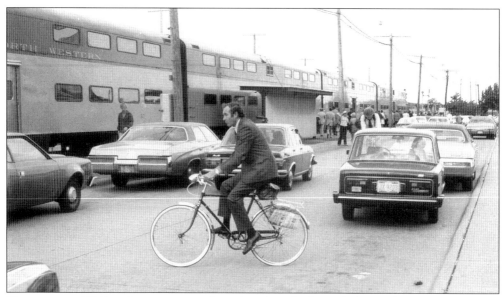

COMMUTER, 1970s. As gas prices skyrocketed and physical fitness became a concern, commuters rode bikes to the train station, weather permitting. Lack of adequate parking was also a factor. By this time, the RTA (Regional Transportation Authority) had been formed, providing service for the six counties in the Chicago area. (Photo courtesy of Arlington Heights Planning Commission.).

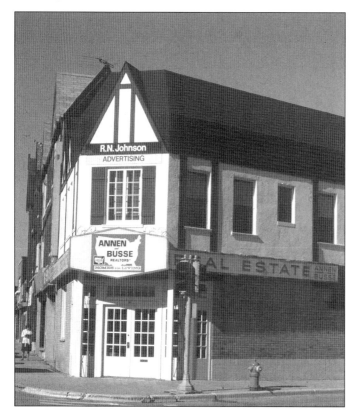

ANNEN AND BUSSE. This real estate office stood at the corner of Evergreen Avenue and Northwest Highway. Houses in Arlington Heights usually sold quickly once they were listed. A home located near the train station had the added advantage of convenience, although residents still did most of their shopping in the malls. (Photo courtesy of Arlington Heights Planning Commission.)

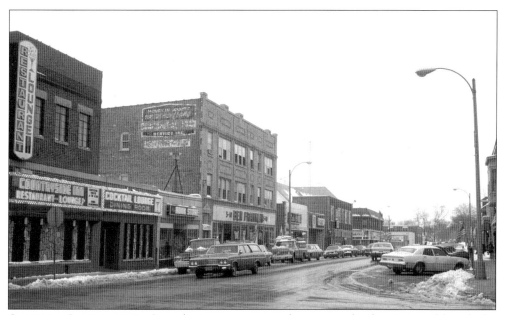

CAMPBELL STREET, 1976. Some businesses were just hanging on by the 1970s. Although the Countryside Restaurant (at the former location of Sieburg's Drugs) lasted about another 20 years, the bookstore was gone by the 1980s. The Ben Franklin Store burned in 1978. Signs of aging were hard to ignore. (Photo courtesy of Arlington Heights Planning Commission.)

BILL'S TAVERN, 1976. Bill Andre tried to keep his establishment going on Campbell Street, but like so many merchants around him, he saw the neighborhood deteriorating and decided to move on. The tavern reopened at a more visible location on Northwest Highway in the early 1980s. (Photo courtesy of Arlington Heights Historical Society.)

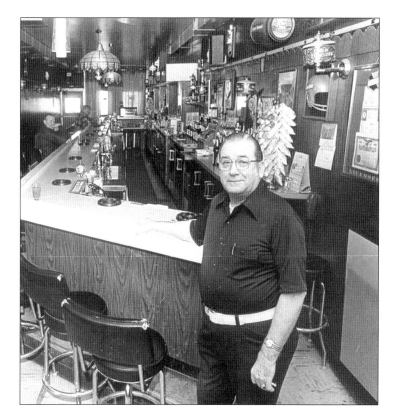

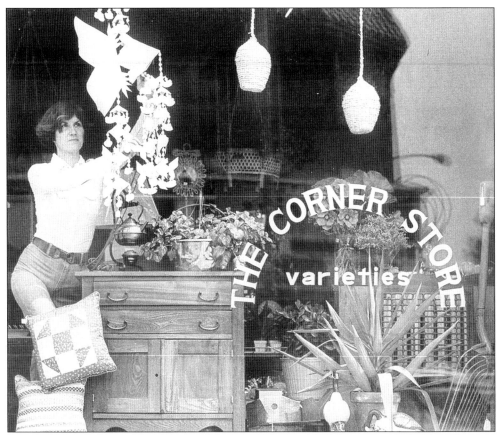

THE CORNER STORE, 1976. In the early 1970s, technology had begun to take hold, resulting in a backlash of sorts for crafts, greenery, and the natural tactile style of decorating. In many homes, plants in macramé holders dangled from ceiling hooks, and candles were not just for dinner tables anymore. This store at 2 North Vail Avenue might have done well in a shopping mall. However, downtown Arlington Heights couldn't support it for long. Still, planners and village officials were talking and knew that a large number of stores catering to current trends had no positive impact on the downtown economy unless there were people drawn into the area to shop. The first necessary step was a change in zoning ordinances. Relatively speaking, that was the easy part. Formulating a viable long-range plan had politicians and engineers debating for almost another decade. It was one thing to agree to change and yet another to decide how the change should be made. (Photo courtesy of Arlington Heights Historical Society.)

ARLINGTON HEIGHTS ROAD, 1970S. This view looks north toward Northwest Highway. Arlington Heights Road was later widened, and some of the trees were cut down. At this time, city planners were discussing the possibility of building a cultural center on Arlington Heights Road, just south of town, but that never materialized. (Photo courtesy of Arlington Heights Historical Society.)

NORTHWEST HIGHWAY AND EVERGREEN AVENUE. This view looks toward the north end of town. The building on the far right is the site of 200 Arlington Place. The Arlington Theatre is just past that building. The train station shelter and the parkway trees were taken down to expand train station parking. (Photo courtesy of Arlington Heights Historical Society.)

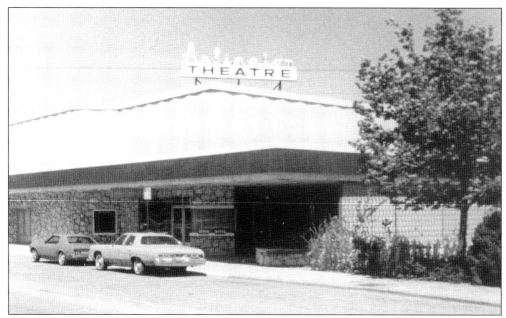

ARLINGTON THEATRE. The theatre had been part of downtown Arlington Heights since the 1920s. By the mid-1980s, people were flocking to the multiplexes that had become an integral part of the mega malls in the area. The Arlington, with bucolic scenes rendered on its walls and fresh coffee in the lobby, had been the place for many first dates. On a summer evening, guests enjoyed the outdoor patio before seeing the movie. (Photo courtesy of the Helen Horath Estate.)

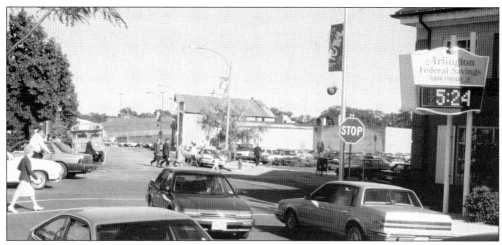

DAVIS STREET, LATE 1970s. This is the corner of Evergreen Avenue and Davis Street. Buildings on the southeast corner had been razed, but no one yet had a definite plan in mind— only an eye to the future. Eventually this became part of the Arlington Town Square. The yellow bus in the background is transportation provided by PACE, the northwest suburbs' local transportation service. (Photo courtesy of Arlington Heights Planning Commission.)

Seven

MAKING NO
SMALL PLANS

In spite of heavy competition from malls and discount stores, the downtown area somehow managed to survive. However, by the early 1980s, retailers could not ignore the signs of decay. Then in 1986, with a new plan called tax increment financing (TIF), village officials took the first steps toward making the downtown area work. First, the Dunton Tower condominiums went up, and people responded favorably. That worked, so 200 Arlington Place with its condos and shops followed. Existing buildings and walkways in the Campbell Street-Dunton Avenue neighborhood were given a new look, and that worked as well. Then the most ambitious project of all took hold. Some buildings were preserved and others razed. What finally arose from the rubble was an award-winning, architecturally-pleasing central business district. The downtown had come alive. As Mayor Arlene Mulder stated: "We have recreated that sense of a center hub where people want to be. I have always believed that change is inevitable but progress is optional."

Many surrounding villages condemned Arlington Heights' hi-rise solution, yet there is one last bit of irony. A recent article in a local paper stated that the so-called "bedroom communities," with no official central area, were now creating their own residential downtowns, connecting malls, libraries, and government offices enhanced with fountains and sculpture. What goes around comes around.

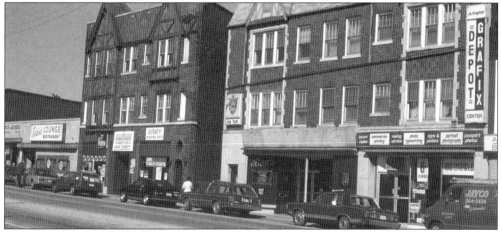

NORTHWEST HIGHWAY, 1984. The downtown area's decline was felt on both sides of the tracks in the mid-1980s. Even the army recruiters had departed. The good news is that Eddie's Lounge, next door to the left, is still there and serving all-you-can-eat fish on Friday nights. (Photo courtesy of Arlington Heights Planning Commission.)

LILYANS STORE, 1983. On the southwest corner of Dunton Avenue and Campbell Street, this store had been in business since 1956. These signs were not unusual in the downtown area during the early 1980s. Twelve stores closed during that time, and no new businesses moved in. (Photo courtesy of Doug Mitchell.)

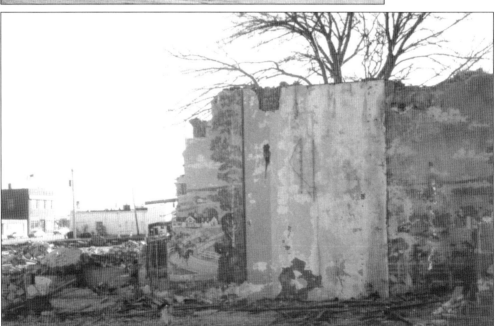

DEMOLISHING THE ARLINGTON THEATRE, 1986. A new high-rise was on its way at this corner. The movie house had been the site of police department Christmas parties for kids, "bank night" during the Depression, and Saturday matinees. In its final years, sometimes the Arlington showed the same movie for two or three months, a sign that perhaps it was on its way out. Note the now-faded murals that were part of its decor. (Photo courtesy of Phil Theis.)

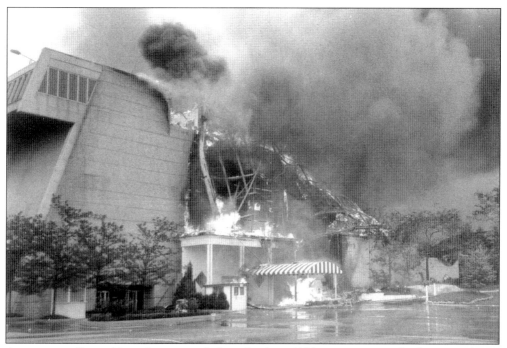

ARLINGTON PARK FIRE. It appeared that the late 1980s were a period of tearing down, sometimes unplanned. This image depicts the Arlington Race Track fire in July 1985. The track was completely destroyed, and it appeared that the symbol of Arlington Heights was gone forever. But with the famed "Arlington Million" race only weeks away, owner Richard Duchossois was determined that the race should run at his park. Crews worked round the clock to create a temporary Arlington Park that would house the race. They finished two days ahead of schedule. On August 25, the horses "were off" as a crowd of over 35,000 watched. (Photo courtesy Arlington Heights Planning Commission.)

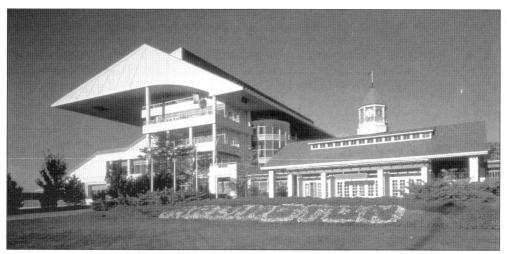

THE NEW ARLINGTON INTERNATIONAL RACECOURSE. The track was rebuilt in 1989, and with it came a new name. This new structure boasts a six-story, 70,000-square-foot grandstand, and clubhouse. The racecourse closed briefly during the late 1990s, but reopened in 2000. (Photo courtesy Arlington Heights International Racecourse.)

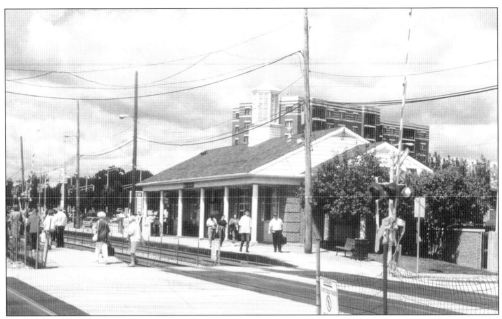

TRAIN STATION, 1980s. This station was built in 1976. Although the colonial treatment seemed more attractive, the station itself was still a basic train depot with a newsstand, ticket booth, and small coffee and doughnut stand in the corner. It served the village well for the next 24 years. (Photo courtesy Arlington Heights Planning Commission.)

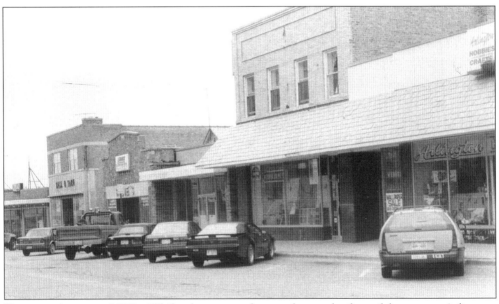

DUNTON AVENUE, 1980s. While plans were afoot to change the face of downtown Arlington Heights, some areas remain unchanged. This shows Dunton Avenue on the north side of the tracks. Some stores have changed ownership, but the concentration at this time centered a block or two away to the east. (Photo courtesy Arlington Heights Planning Commission.)

CAMPBELL STREET CONSTRUCTION, 1987. In 1986, a group of merchants who comprised the Central Business District Association decided it was time to revitalize the downtown area. To make it more "walker friendly" and to encourage people to stroll, the cement sidewalks were replaced with brick, and the storefronts sported new facades. (Photo courtesy of Arlington Heights Planning Commission.)

DUNTON TOWER CONSTRUCTION, 1986. About one block south of Campbell Street on Vail Avenue, the Dunton Tower was one of two high-rises that began to change the face of downtown in the late 1980s. This building offered parking across the street, with a catwalk connecting the two buildings. An area that someone described as having "fallen asleep" was slowly beginning to wake. (Photo courtesy of Arlington Heights Planning Commission.)

CONSTRUCTION OF 200 ARLINGTON PLACE. Thanks to a plan called Tax Increment Financing, the village has been able to lure developers into the downtown area. As new buildings are erected, the property values increase, thus increasing tax revenues. These revenues go toward paying for the financing of the original structures. (Photo courtesy of Phil Theis.)

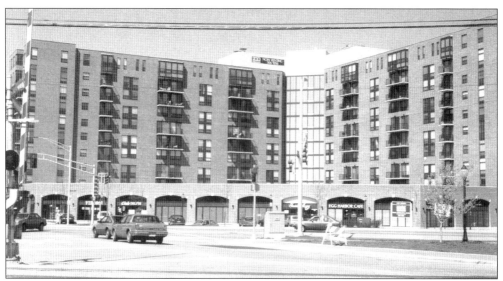

200 ARLINGTON PLACE. This structure on the north side of the tracks replaced the Arlington Theatre in the area bound by Evergreen Avenue, Eastman and Wing Streets, and Arlington Heights Road. Small businesses and shops occupied the first floor, and the rest of the building was comprised of condominiums. A swimming pool sits in the center behind the shops. (Photo courtesy of Arlington Heights Historical Society.).

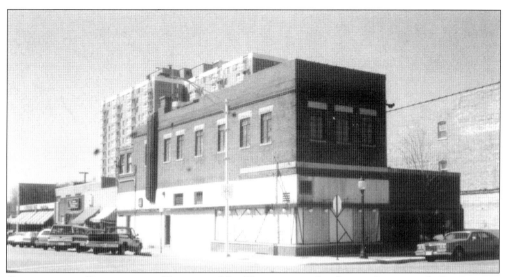

COUNTRYSIDE RESTAURANT BOARDED UP. Here we see the former Countryside Restaurant, which at one time had been Sieburg's Drug Store, now boarded up and destined to be torn down. No building replaced it, and a small park-like area now occupies that corner. (Photo courtesy Phil Theis.)

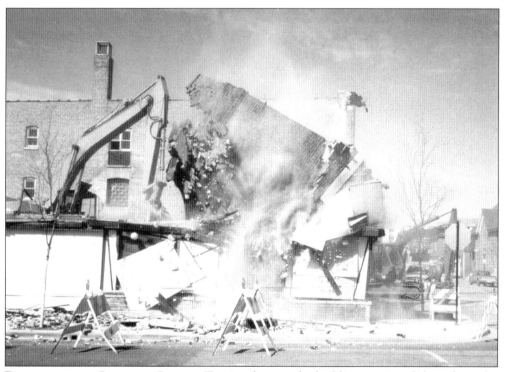

DEMOLITION ON CAMPBELL STREET. Tearing down and rebuilding continued throughout the latter part of the 1980s. This shows the Countryside Restaurant (at the southwest corner of Dunton Avenue and Campbell Street) and the magazine/tobacco store next to it, going out in a blaze of, well, not exactly glory, but their final moments were captured on film. (Photo courtesy Phil Theis.)

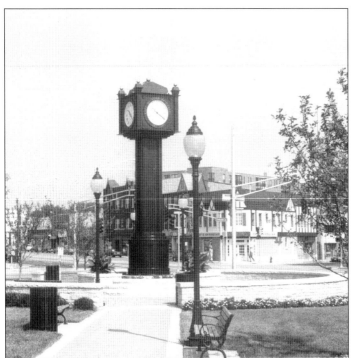

CLOCKTOWER PLAZA. The plaza was part of the redesign project of the downtown area. In an effort to recapture the feel of the original Railroad Park, the village created this plaza between Arlington Heights Road and Evergreen Avenue on the north side of the tracks. The clock tower, designed by local sculptor Joseph Burlini, was dedicated in 1986. This view looks north toward Evergreen Avenue and Northwest Highway. (Photo courtesy Arlington Heights Planning Commission.)

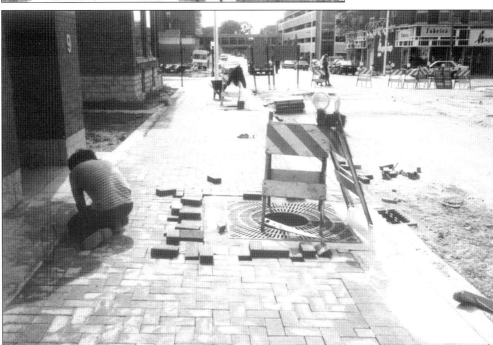

BRICK WALKWAY CONSTRUCTION. Hand-laid pavers were the final step in the construction of the walkway that snaked through the general area of Campbell Street, Dunton and Vail Avenues. It then crossed the tracks, ending at Clocktower Plaza. The walkway became known as "Arlington Trail." Trees and benches soon followed. (Photo courtesy Arlington Heights Planning Commission.)

DUNTON COURT. Built in the 1960s, this strip mall on Dunton Avenue is about a block south of Campbell Street. Several frame houses had to be moved to accommodate the mall, but it has survived despite the flurry of construction surrounding it. Some stores have come and gone, but Persin and Robbins Jewelers and Harris Pharmacy are still there. (Photo courtesy Arlington Heights Planning Commission.)

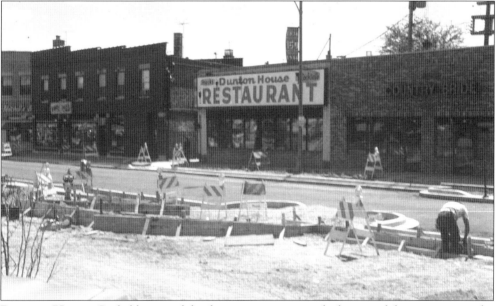

DUNTON HOUSE. Probably one of the first structures to catch the eye of the commuter as he rides into town is this restaurant at 11 West Davis Street. The signage and general architectural style are a throwback to another era, but to its credit, the Dunton House has survived. (Photo courtesy Arlington Heights Planning Commission.)

CAMPBELL STREET. This view is looking west from Dunton Avenue toward Vail Avenue. Some rejuvenation of downtown is now evident, giving new life to the faded town center that had almost been left for dead. At the far corner of Vail Avenue and Campbell Street is Hagenbring's, which still has a few more years to go before it becomes history. (Photo courtesy Arlington Heights Planning Commission.)

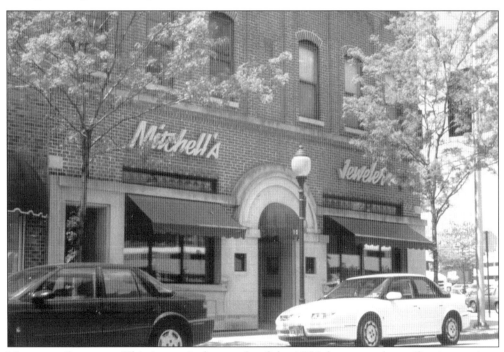

MITCHELL JEWELERS. This is a typical example of the 1986 downtown beautification project. Compare the brick facade, arched doorway, and new awnings to the earlier photograph of Lilyan's store at this spot in 1983. Mitchell's store moved here to Dunton Avenue from its original location on Davis Street. (Photo courtesy Doug Mitchell.)

DOWNTOWN BEAUTIFICATION. The area around Campbell Street and Dunton Avenue began to come alive once again in the late 1980s, once the beautification project was completed. People who had previously driven through the central business district on their way to somewhere else (usually Woodfield or Randhurst Malls) now found it a pleasant place to stroll while munching an ice-cream cone on a summer evening. Many of the stores that existed during the renovation are still there, including Mitchell's and Flaherty's jewelers on Dunton Avenue, Design Tuscano (a European decorative arts gallery that expanded as the downtown developed over the years) on Campbell Street, and Harry's Bar at the corner of Vail Avenue and Campbell Street. Although the neighborhood was a long way from catering to every shopper's whim, over the years the area did acquire art galleries, bookstores, and a gourmet coffee shop before the big building boom hit. (Photo courtesy Arlington Heights Planning Commission.)

NEW POLICE STATION, 1980S. The village government got a bit of a facelift as well during the late 1980s. A new police and fire station addition was built east of the village hall. The police department communications and services have been kept up to date with state of the art dispatch and alarm systems. In addition to the fire station in the center of town, there are three other firehouses in the village. (Photo courtesy Arlington Heights Planning Commission.)

NORTHWEST CORNER OF CAMPBELL STREET AND VAIL AVENUE. The building shown here was a Chinese carry-out restaurant, destined for demolition to make way for the Village Green condominium project. (Photo courtesy Phil Theis.)

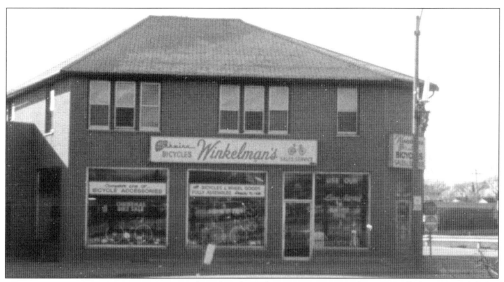

Winkelman's Bike Shop, 1984. Shortly after this picture was taken, Winkelman's sold the operation to Amling's Cycle and Fitness. When this building was torn down in the late 1980s as part of the downtown revitalization plan, Amling's moved to 200 West Campbell Street. That shop was later demolished for the major buildup of the downtown area. (Photo courtesy Arlington Heights Planning Commission.)

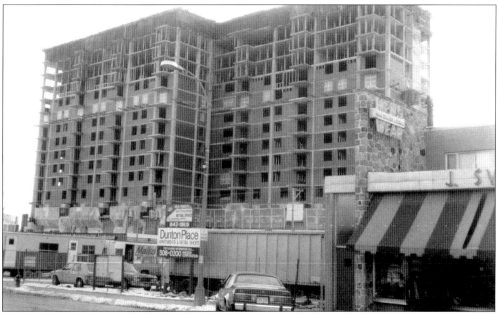

Dunton Tower Construction, 1986. The first high rise in Arlington Heights was the Dunton Tower, built in 1986. This shows the building from the Campbell Street side, although the front of the building faces Vail Avenue. Svoboda's Men's Wear stayed for another 15 years, but it recently closed, much to the dismay of people who had counted on Svoboda's for 45 years. Both Svoboda's and Hagenbrings had survived the gradual deterioration of the central business district during the 1970s, yet managed to enjoy the 1980s' rebirth of the downtown area. (Photo courtesy Phil Theis.)

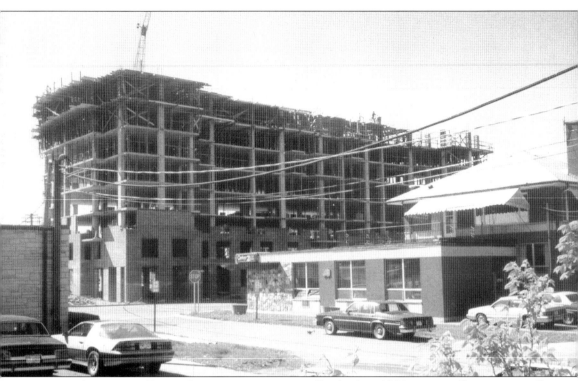

200 ARLINGTON PLACE CONSTRUCTION, 1987. By the late 1980s, some villagers were still not sold on the sight of skeletal structures such as this dotting the center of town. But the governing bodies knew that if the number of residents in the downtown area remained static, any central business district retailers were doomed. An appropriate mix of retail stores and multi-family housing was necessary for the downtown to remain a vital part of the community and to help increase the tax base. The stores and restaurants that were destined to occupy this building are still here as of this writing, and the residential occupancy is nearly 100 percent. Other than the fact that there are no hotels in the central business district, Arlington Heights' downtown is beginning to resemble the early days of the village when its residents lived near where they shopped. (Photo courtesy Phil Theis.)

HARRY'S OF ARLINGTON. One of the few buildings from the nineteenth century still standing, this one at Campbell Street and Vail Avenue was originally the Redeker General Store, shown at the end of Chapter One. Over the years, it has been Sah's Grocery, and years later, a pool hall. After the pool hall closed down during downtown's business slump in the 1970s, the structure was unoccupied for at least ten years. In 1984, it was refurbished to conform to building codes and became The Billy Club, a casual dining restaurant. It is now Harry's of Arlington. The hardwood floors are still there, as well as the second floor for overflow dining. An outdoor patio is just to the left of the building. Just past that is the Vail St. Café, for those who feel the need for a cappuccino after their beer and hamburgers. (Photo courtesy Phil Theis.)

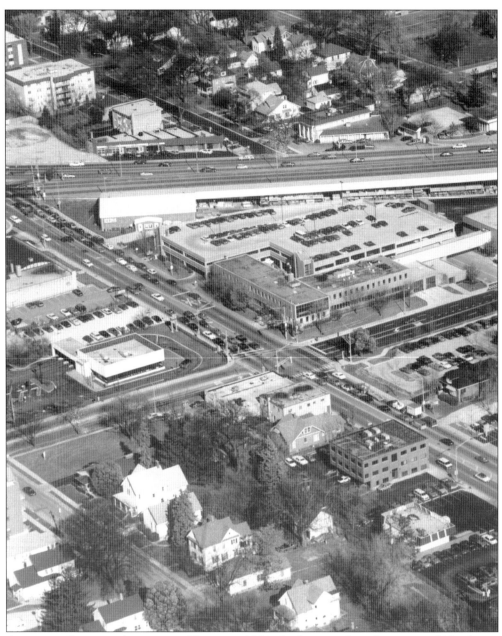

AERIAL OF CENTRAL ARLINGTON HEIGHTS, 1991. Looking north and east toward Northwest Highway, this is Arlington Heights as it headed into the 1990s. Arlington Heights Road runs top left toward bottom right, through the center of the photograph. Sigwalt Street crosses it near the center. The municipal building is on the northeast corner of Sigwalt Street and Arlington Heights Road. A lumberyard (soon to be closed) is just north of that. This triangle of land was the original location of Meyer's Pond from 1883 to 1934. On the west side of Arlington Heights Road is the Citibank drive-in facility, and just north of that is Aspen Ski and Patio. This area stayed fairly static until 1997, when the Freed building project, Arlington Town Square, was begun. Most of the homes in the lower half of the photo are still standing. (Photo courtesy Arlington Heights Planning Commission.)

108

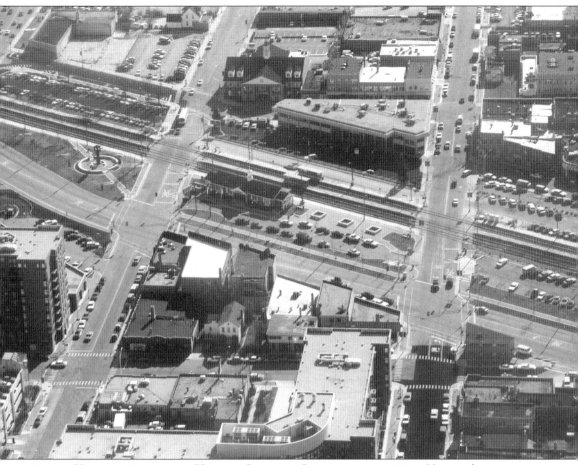

AERIAL VIEW OF ARLINGTON HEIGHTS LOOKING SOUTH, EARLY 1990S. Here is downtown Arlington Heights looking south. The wide street on the left is Evergreen Avenue. Northwest Highway crosses it at the grassy area, which is Clock Tower Plaza. The street to the right of Evergreen Avenue is Dunton Avenue. Across from the plaza, to the right, is the train station. On the south side of the tracks are two banks. The wedge-shaped building is Bank One, originally People's Bank before the Depression. This was also the site of the Union Hotel, before it was razed in the late 1950s to allow for expansion of the bank building. The colonial style building across from Bank One is now Citibank, originally Arlington Federal Savings and Loan. On the north side of the tracks are two high-rise apartment complexes, one at bottom center and the other on the far left of the photo. (Photo courtesy Arlington Heights Planning Commission.)

BAND CONCERT, NORTH SCHOOL PARK. Just north of downtown, this was originally a parking lot for North School on Arlington Heights Road. North School is now the headquarters for the Arlington Heights Park District. The park was constructed in 1991, and since then has provided entertainment in the summer as well as a perfect background for wedding pictures. At Christmas, several lighted sculptures, such as a windmill, train, and airplane, adorn the grounds. (Photo courtesy Arlington Heights Planning Commission.)

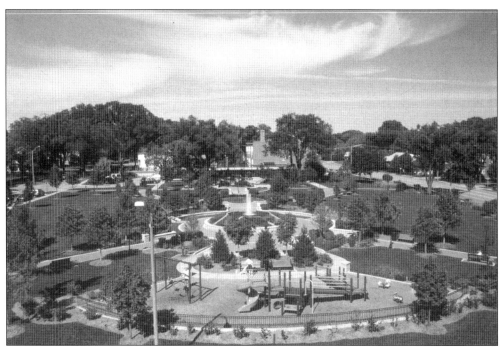

VIRGIL HORATH FOUNTAIN, NORTH SCHOOL PARK. In the center of this view of North School Park is the Virgil Horath fountain. During the late 1980s, when the site was first considered for a building project, Virgil's wife Helen fought to have a park created there, stating that the property was donated to the community by William Dunton on the condition that it would always remain open. This fountain was named in honor of Helen Horath's late husband. (Photo courtesy of the Helen Horath Estate.)

HAGENBRINGS, CORNER OF CAMPBELL STREET AND VAIL AVENUE. Hagenbring's Dry Goods began as a five- and ten-cent store in the late 1920s, on Campbell Street between Vail and Chestnut Avenues. As the years went on, the business expanded to include the corner property. Hagenbring closed the shop in the late 1990s, when he decided to retire. The original building remains and is now an art gallery. (Photo courtesy Arlington Heights Planning Commission.)

VAIL-DAVIS BUILDING, EARLY 1990s. Built in the late 1920s, this structure has been home to a number of businesses—a hardware store, a paint and wallpaper store, and a hair salon. The architecture still gave the area a touch of elegance, even during the blight that invaded the downtown in the 1970s. (Photo courtesy Arlington Heights Planning Commission.)

VAIL ST. CAFÉ. This coffeehouse opened in the mid-1990s, a period that saw the Campbell-Vail-Dunton area rejuvenate itself. The move toward more eclectic forms of caffeine spread across the country; Vail St. Café fit into that trend by offering lattes, cappuccino, and espresso accompanied by muffins, bagels, scones, and live entertainment on weekends. (Photo courtesy Arlington Heights Planning Commission.)

ASPEN SKI AND PATIO, 1997. This shop stood at the corner of Northwest Highway and Davis Street. It had replaced a two-story brick building that had housed "Uncle Alberts Records and Tapes" during the 1970s. When this picture was taken, the store was destined to be torn down and replaced by Arlington Town Square, a condominium and retail store complex. (Photo courtesy Phil Theis.)

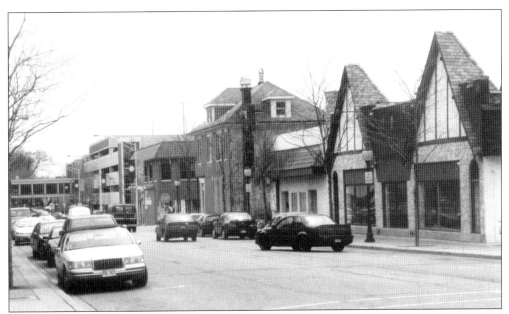

WEST SIDE OF VAIL AVENUE, 1997. Looking south toward Campbell Street, the peaked buildings on the right had been originally known as the Engelking Building, constructed in the 1920s. The property next door used to be a bowling alley in the 1920s. At the corner is the Chinese carry-out. These buildings were torn down to make way for the Village Green complex. (Photo courtesy Phil Theis.)

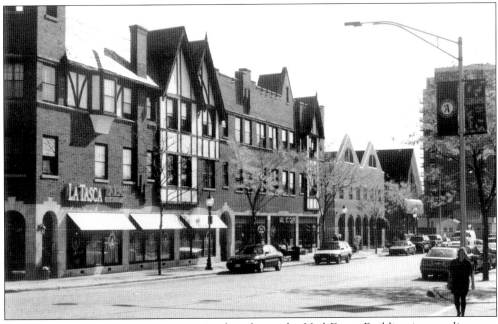

EAST SIDE OF VAIL AVENUE, 1997. In this photo, the Vail Davis Building is appealing to a more upscale clientele. La Tasca is a tapas restaurant which also features entertainment on weekends. Down the street are various offices, shops, the Vail St. Café, and at the corner, Harry's Bar and Grill. (Photo courtesy Phil Theis.)

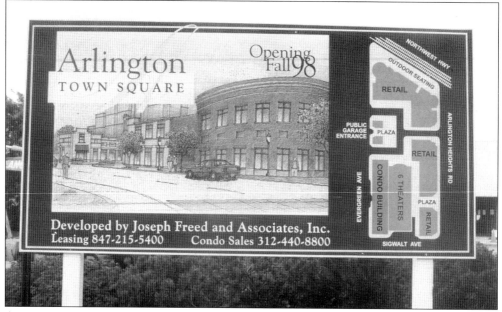

ARLINGTON TOWN SQUARE SIGN. Toward the end of 1996, the village board announced plans to tear down the area surrounded by Arlington Heights Road, Sigwalt Street, Evergreen Avenue, and Davis Street to replace it with a complex of shops, restaurants, and apartments. This move also included closing Davis Street to accommodate the walkway surrounding the structure. The plans met with strong opposition from a group known as the "Shadow Project." But in the end, progress won and construction began. (Photo courtesy Phil Theis.)

CONSTRUCTION BEGINNING ON ARLINGTON TOWN SQUARE. Digging for Arlington Town Square began in 1997. In addition to criticism from all corners, other problems arose during the next two years. Phone service was disrupted twice when workers misjudged the depth of the cables when digging. Road travel became a cruel game of "Streets and Alleys" when first one avenue was blocked off, and then another as motorists desperately groped their way through town. (Photo courtesy Phil Theis.)

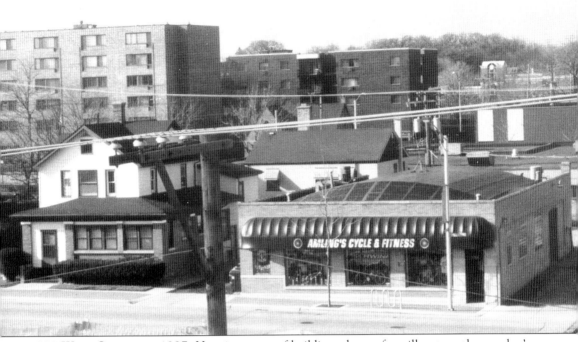

200 WEST CAMPBELL, 1997. Here is one set of buildings that so far will not see the wrecker's ball. The story of Amling's Cycle and Fitness sounds like a complex running of "musical bikes," but also showed that it was possible to survive the uprooting that many business owners in the downtown area suffered during the construction. In 1984, John Amling took over Winkelman's Bike Shop on Davis Street. In 1997, he moved to 200 West Campbell Street when his shop was torn down to make way for the Arlington Town Square construction. Then the Village Green project at Vail Avenue and Campbell Street meant demolishing that block, forcing Amling once again to pick up his operation and move. About this time, Amling and John Helmkamp, who owned ABC Cyclery at 45 South Dunton Avenue, began talking seriously about joining forces. Their products actually complemented each other, so there was really no competition between them. Amling briefly occupied a shop at 115 West Campbell Street until he could combine his operation with Helmkamp at 43–45 South Dunton Avenue. (Photo courtesy Phil Theis.)

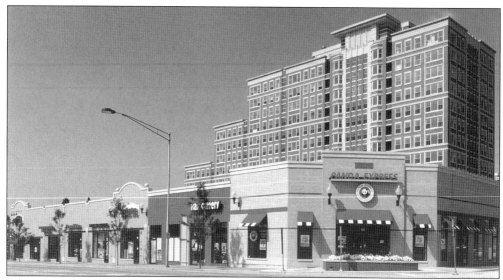

ARLINGTON TOWN SQUARE COMPLETED, 1999. It was an idea whose time had come, and it appeared that people who thought this idea spelled doom were ready to accept it. This view looks south down Arlington Heights Road. The condominium in the background towers over the one-story shops and restaurants in front. Just to the right of Panda Express is a walkway leading toward shops and a movie house. (Photo courtesy Joseph Freed and Associates.)

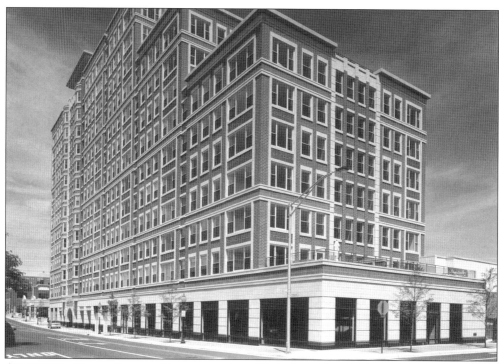

ARLINGTON TOWN SQUARE CONDOMINIUMS. This shows the condominium portion of the complex at Evergreen Avenue and Sigwalt Street. Shops are on the ground floor. The building consists of two and three-bedroom units, about 80 percent of which are occupied. (Photo courtesy Joseph Freed and Associates.)

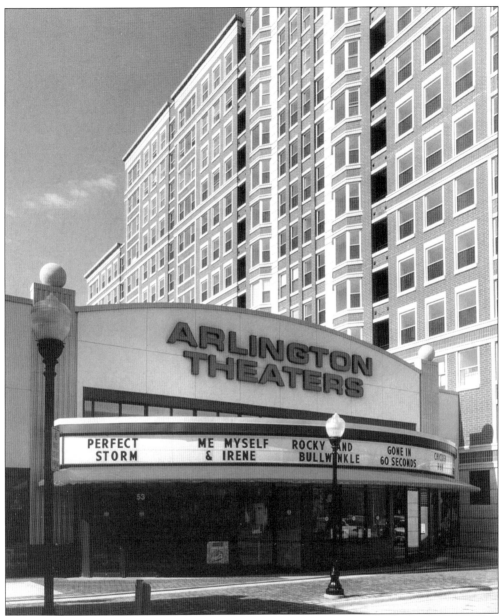

ARLINGTON THEATRES. After more than ten years without a theatre in the downtown area, Arlington Heights now had its own multiplex for the convenience of people living near the center of town. This Arlington Theatre boasted six screens and no waiting. The movie house, part of the Town Square complex, opened in December 1999, shortly before Christmas. To lure regular moviegoers, admission was free the first week. However, it was necessary to obtain an exemption for the marquee sign, a second wall sign facing north toward the plaza, and poster boards to advertise currently shown movies. This signage had exceeded the village code, which allows stores one square foot of sign area for each lineal foot of frontage. In the plaza surrounding the theatre are sandwich and coffee shops, clothing stores, and specialty shops. Unlike other structures downtown, parking for Arlington Town Square is underground, with spaces for 325 cars. (Photo courtesy Joseph Freed and Associates.)

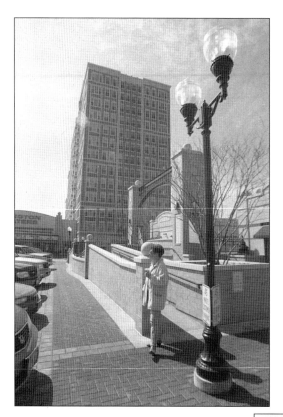

ARLINGTON TOWN SQUARE PLAZA. In the center of the plaza are walkways, benches, and a fountain. Amid the ballyhoo of upscale development, merchants in the Campbell-Dunton area found that, after enduring dust, noise, blocked-off streets, and diminishing retail sales, they were rewarded with skyrocketing rents and taxes. Unlike the exodus of the 1970s and 1980s, however, other merchants have taken the place of those who relocated to less expensive areas. (Photo courtesy Joseph Freed and Associates.)

PONIES ON PARADE. In 1999, the City of Chicago scattered life-size, hand-painted cows along the lakefront and downtown area. Not to be outdone, the following year, Arlington Heights developed its own artistic symbols, "Ponies on Parade." Businesses and private citizens purchased and decorated fiberglass ponies to celebrate the re-opening of the Arlington International Racecourse and Arlington Heights downtown rejuvenation. The ponies were later auctioned just prior to the Arlington Million Race. (Photo by Lauretta Haug for the Arlington Heights Chamber of Commerce.)

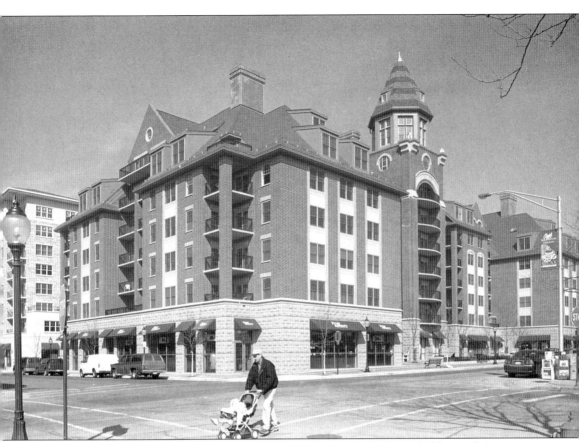

VILLAGE GREEN. By the year 2000, the Village Green complex bounded by Vail Avenue, Campbell Street, Wing Street, and Chestnut Avenue was complete, but not without its share of headaches. In 1998, excavation was halted when it was noted that the foundation walls, instead of sloping in to avoid a possible street cave-in, had been dug too steep. Nevertheless, the project proceeded according to schedule and opened about the same time as the Arlington Town Square project, another step in creating high-density housing and businesses necessary to keep the downtown alive. This is the northwest corner of Campbell Street and Vail Avenue, the site of the former Chinese carry-out, bowling alley/karaoke bar, and those "twin-peaked" buildings shown earlier. The Village Green is a well-proportioned mix of residences, restaurants and shops. (Photo by Gerry Souter.)

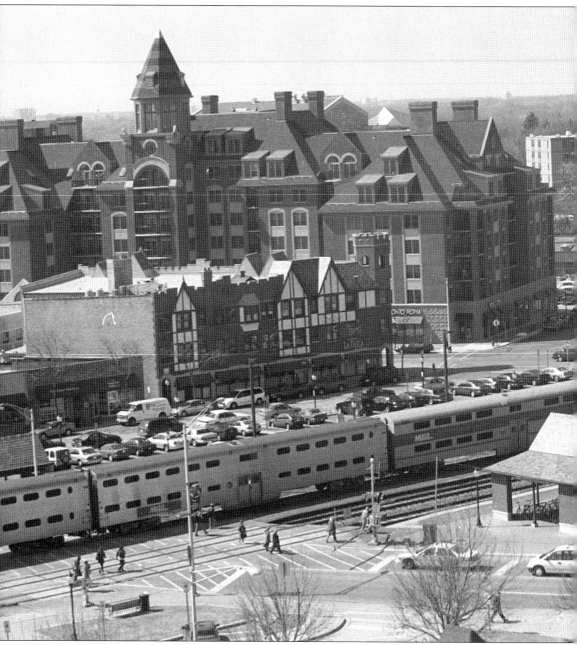

VIEW OF DOWNTOWN ARLINGTON HEIGHTS, 2001. The village shown here is a far cry from the clapboard structures of the nineteenth century. The building to the left (with the turret) is the Village Green. In front of that, the Vail-Davis Building, constructed in 1928, is yet holding its own with the twenty-first century architecture surrounding it. Off to the right and to the west is the new Jewel Food Store, which was once the site of the two-story village hall and town

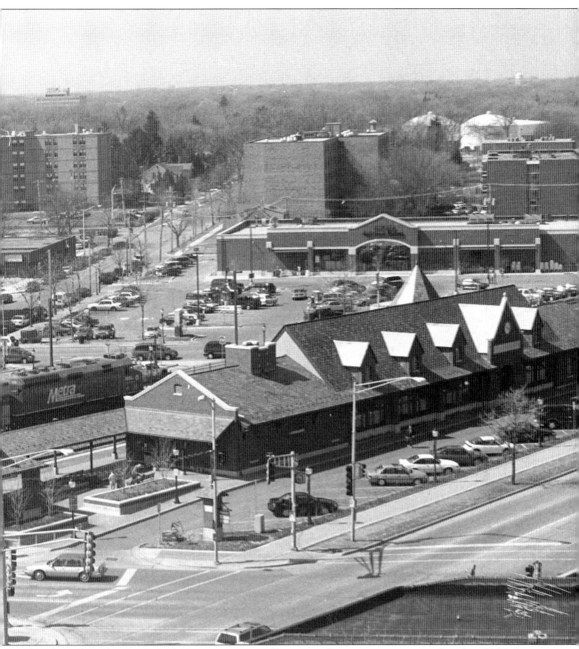

bandstand in the 1920s and '30s. A train is pulling into the new station, completed in 2000. It stands now between Dunton Avenue and Vail Avenue, just west of the original building. This depot offers more than just a place to sit and wait. Travelers can enjoy coffee, select bakery goods, or feast on the old standby, a "Big Mac ©." (Photo by Gerry Souter.)

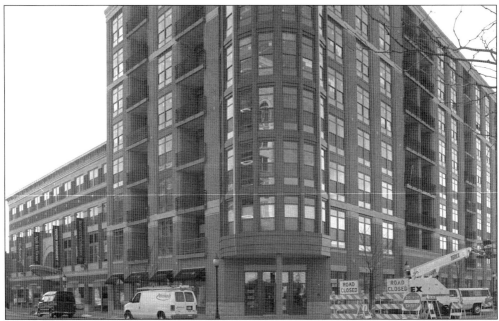

METROPOLIS PLACE CONDOMINIUMS. Located on Campbell Street near Chestnut Avenue, across the street from the Campbell Courte, the five-story Metropolis Place offers loft-style condominiums in addition to retail space and parking in nearby garages. For those who enjoy live performances, the Metropolis Performing Arts Center is off to the left. (Photo by Gerry Souter.)

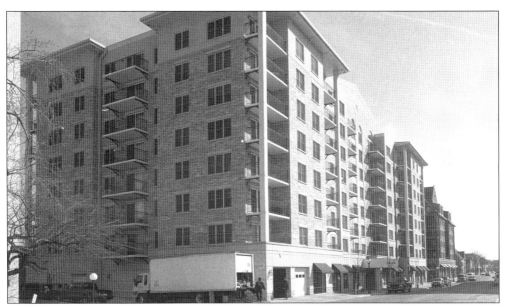

CAMPBELL COURTE. This complex is located on Campbell Street just west of the Village Green. It's a pleasant alternative for people who may not want to be in the very heart of downtown but want the shopping and dining convenience. The architecture of each of the most recent condominium complexes is distinctive yet not severe, respecting the restored buildings dating back to the nineteenth century, still standing on the south side of the railroad tracks. (Photo by Gerry Souter.)

METROPOLIS PERFORMING ARTS CENTER. This brainchild of developer Mark Anderson, who played a large part in revitalizing the downtown area, gave the village something brand new—live theatre. Concerts, plays, children's theatre, and other venues are offered during the year. Behind the theatre is an open-air courtyard for theater-goers and fund raisers. (Photo by Gerry Souter.)

MAYOR ARLENE MULDER. In 1993, Arlene Mulder took office as the village's first female mayor. She is now in her third term, having run unopposed in the last two elections. Prior to that, she had served as village trustee and on the board of the Arlington Heights Park District. Mulder was instrumental in forging the plans to revitalize the central business district area. (Photo courtesy Arlene Mulder.)

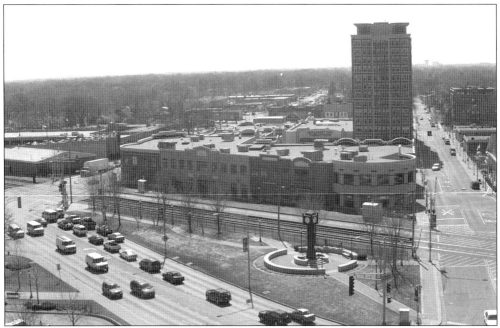

CLOCK TOWER PLAZA. This view looks south toward Arlington Town Square. Davis Street between Evergreen Avenue and Arlington Heights Road is gone to make room for the shops and offices along that side of the tracks. To avoid a rubber stamp, boxy look, the builders designed rounded corners and alternated the brick colors. The residential area rises in the background. (Photo by Gerry Souter.)

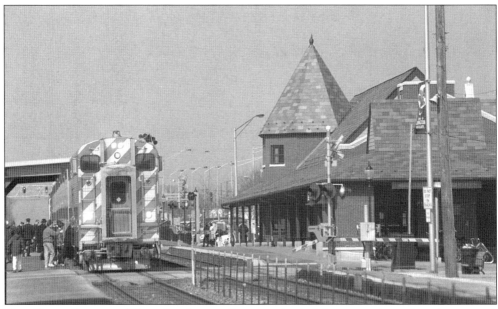

NEW TRAIN STATION. When the planners first conceived of the new train station, they wanted to incorporate the look of sloped roofs, copper trim, dark brick and turreted treatment of the Victorian era to blend in with the other new projects on the boards at that time. Thousands of commuters enjoy the amenities of the multi-use facility every day. (Photo by Gerry Souter.)

NEW JEWEL FOOD STORE. In the late 1990s, when Jewel announced it was closing this store at Vail Avenue and Wing Streets, the residents in the area, particularly senior citizens, launched a giant protest. For years, this had been the only supermarket in the downtown area. Jewel relented and kept the store going. The year 2000 saw the store completely refurbished and expanded, to accommodate the influx of condominiums in the area. (Photo by Gerry Souter.)

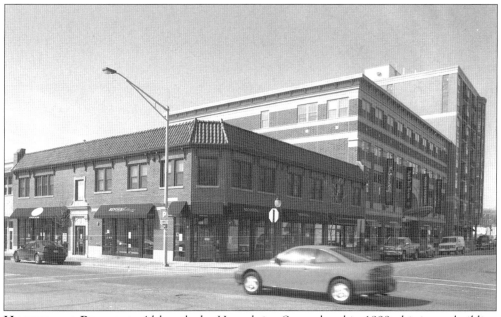

HAGENBRING BUILDING. Although the Hagenbring Store closed in 1999, this is one building that didn't meet with the wrecker's ball. In an effort to keep the district from resembling a concrete canyon, many of the buildings dating back to the 1920s and '30s have been retained. This decision also helped give the central business district the appearance that the village had developed over the years. (Photo by Gerry Souter.)

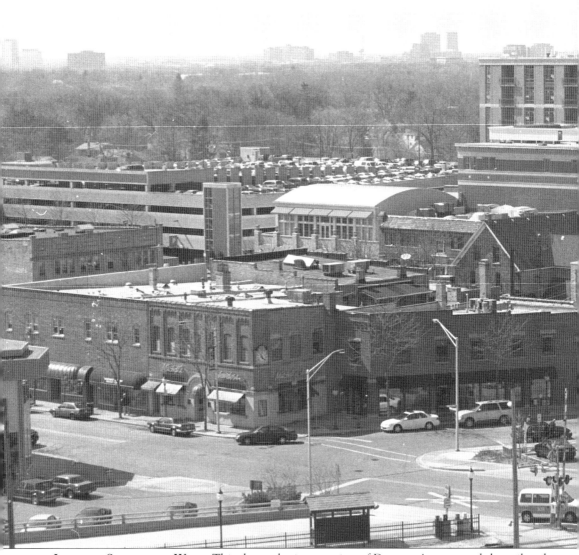

LOOKING SOUTH AND WEST. This shows the intersection of Dunton Avenue and the railroad tracks. The turreted Village Green complex gives the neighborhood a focal point, and the buildings themselves are reminiscent of the Chicago-style architecture. Careful planning went into each project; developers, the planning commission, and village officials were all involved to make certain that structure designs should be interesting to the eye yet avoiding a gingerbread look. The result: several awards, including the Metropolitan Planning Council's

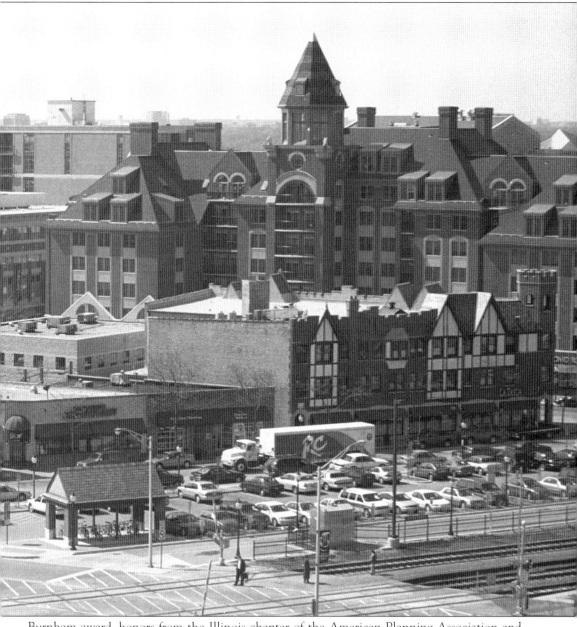

Burnham award, honors from the Illinois chapter of the American Planning Association and the Chicago Area Transportation Study (for the METRA Station), and a gold medal in the James Howland Awards for Urban Enrichment from the National League of Cities. Visitors travel from towns and villages around the country to Arlington Heights in order to tour this successful model of community planning. (Photo by Gerry Souter.)

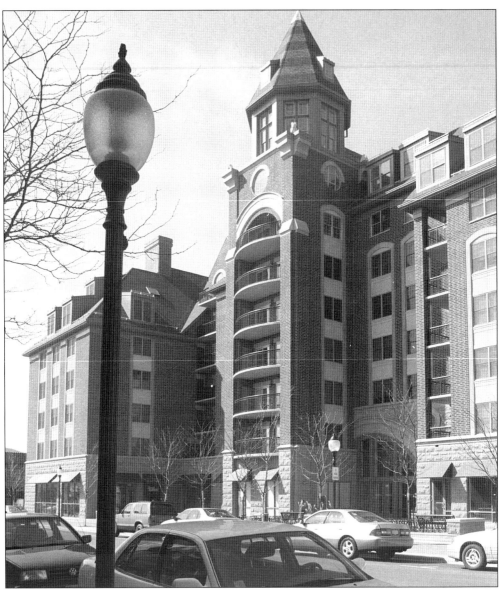

VILLAGE GREEN ENTRANCE. "Where can I buy a condo?" That's what people are asking, according to one real estate agent in Arlington Heights. When developers conceived of these projects, one of their main goals was to keep the warmth and friendliness of Arlington Heights without sacrificing convenience. The people who live here can walk to the theatre, movies, the train station, and shopping. Nearby North School Park features live concerts in the summer and tree lighting at Christmas. Several restaurants and cafés in the area offer a wide choice of cuisines, and more are planned. Transportation is even available to take downtown residents to the nearby malls. Some new residents no longer feel the need to own a car. Future plans for the village include developing the area north of the tracks, and more construction at the site of the old Daily Herald building. Long time residents, though skeptical at first, now accept and enjoy the new dynamic heart of their village. New generations will grow up in the village center like they did back in the nineteenth century, when "life moved at the pace of a walking horse and everything was easy to hand." (Photo by Gerry Souter.)